Show of Hands | NORTHWEST WOMEN ARTISTS 1880–2010

Maria Frank Abrams	Ruth Kelsey
Kathleen Gemberling Adkison	Alison Keogh
Eliza Barchus	Maude Kerns
Harriet Foster Beecher	Sheila Klein
Ross Palmer Beecher	Gwendolyn Knight
Susan Bennerstrom	Margot Quan Knight
Marsha Burns	Margie Livingston
Margaret Camfferman	Helen Loggie
Emily M. Carr	Blanche Morgan Losey
Lauri Chambers	Sherry Markovitz
Doris Chase	Agnes Martin
Diem Chau	Ella McBride
Elizabeth Colborne	Lucinda Parker
Claire Cowie	Viola Patterson
Louise Crow	Mary Ann Peters
Imogen Cunningham	Susan Point
Marita Dingus	Mary Randlett
Caryn Friedlander	Ebba Rapp
Anna Gellenbeck	Susan Robb
Virna Haffer	Elizabeth Sandvig
Sally Haley	Norie Sato
Victoria Haven	Barbara Sternberger
Zama Vanessa Helder	Maki Tamura
Karin Helmich	Barbara Earl Thomas
Mary Henry	Margaret Tomkins
Abby Williams Hill	Gail Tremblay
Anne Hirondelle	Patti Warashina
Yvonne Twining Humber	Marie Watt
Elizabeth Jameson	Myra Albert Wiggins
Fay Jones	Ellen Ziegler
Helmi Dagmar Juvonen	

Show of Hands

NORTHWEST WOMEN ARTISTS 1880–2010

Barbara Matilsky

WHATCOM MUSEUM, BELLINGHAM, WA

This book is published in conjunction with the exhibition *Show of Hands: Northwest Women Artists 1880–2010*, organized by the Whatcom Museum and on view from April 24–August 8, 2010. Funding for the exhibition and the accompanying catalogue was supported in part with funds provided by the Western States Arts Federation (WESTAF) and the National Endowment for the Arts (NEA). The City of Bellingham also generously funded the catalogue. Additional support was provided by the Washington Art Consortium (WAC).

ISBN: 978-0-615-35172-8
Library of Congress Control Number: 2010922837

Cover details, front to back:

Margie Livingston, *Angle, Drizzle, and Dot*, 2010, see page 22; Anna Gellenbeck, *Richardson Highway, Alaska*, 1944, see page 42; Maude Kerns, *Composition #85 (In and Out of Space)*, 1951, see page 13; Yvonne Twining Humber, *Ruin*, c. 1949, see page 46; Elizabeth Jameson, *Forecasting Queen*, 2009, see page 25; Blanche Morgan Losey, *Sands of Time*, c. 1945, see page 45

Published in the United States by
Whatcom Museum
121 Prospect Street
Bellingham, WA 98225
www.whatcommuseum.org

Designed by Zach Hooker
Edited by John Pierce
Typeset by Brynn Warriner
Proofread by Carrie Wicks
Color management by iocolor, Seattle
Produced by Marquand Books, Inc., Seattle
 www.marquand.com
Printed and bound in China by Artron Color Printing Co., Ltd.

CONTENTS

Foreword

SHOW OF HANDS: NORTHWEST WOMEN ARTISTS 1880–2010 is a comprehensive study of women artists in the Northwest that happily coincides with the centennial of women's right to vote in Washington State. What better way to celebrate the empowered voices of Northwest women than through their art?

I don't doubt that Abby Williams Hill (1861–1943), one of the earliest artists featured in our show, cast her first vote in 1910 with pride and vigor. As a painter of the Northwest frontier, she was a pioneer in every sense—a professional female artist at a time when most artists were male, and one who spent much of her time in rugged wilderness, no less, camping with her children and painting majestic mountain and coastal scenes commissioned by the railroads to promote travel to the region. She was also a strong voice for those in need, including blacks, immigrants, and poor working mothers, and as a founding member of the Congress of Mothers (predecessor to the PTA), she was a champion of early childhood education. And yet, like many of the women featured in *Show of Hands*, her body of work—more than a hundred paintings—has been largely unseen after her initial rise to prominence at the turn of the twentieth century.

That women artists of the Northwest have often been overlooked is one reason why we are so excited to gather their work in one place with *Show of Hands*. Another is that the Whatcom Museum has been dedicated to the research and exhibition of important Northwest artists since the museum's inception, including women artists (most recently, the seventy-fifth anniversary exhibition of the Women Painters of Washington, held in 2005). We are proud to note that several women represented in *Show of Hands* have been subjects of

solo exhibitions at the Whatcom Museum, and we are grateful for the solid footing these earlier shows provided in mounting an exhibition of the scope and depth of *Show of Hands*.

Through more than ninety works of sixty-one artists from Washington, Oregon, and British Columbia, *Show of Hands* draws on the myriad talents women of the Northwest have revealed in all media, including painting, drawing, sculpture, photography, video, and installation. Showing a historical view from recent to earlier times, the exhibition also draws on the rich and varied holdings of the Whatcom Museum—some little known and never shown before—and those of several other institutions whose collection of women artists precedes the active collecting practice by art museums that in the early days favored male artists. It should come as no surprise that women artists from that time were also tending to other important duties, such as raising children and keeping an entire household. Their painting was often seen as a hobby and not recognized as widely as their male counterparts' works.

The Whatcom Museum is pleased to present *Show of Hands: Northwest Women Artists 1880–2010* and is grateful to the Western States Arts Federation (WESTAF) and the National Endowment for the Arts (NEA), as well as the City of Bellingham and the Washington Art Consortium (WAC), for their support. We are also indebted to the insightful research, knowledge, writing, and curatorial skills of Barbara Matilsky. Her tireless quest to fully explore a topic at multiple levels and her discerning ability to present a tableau that both informs and enlightens are a gift to all who experience *Show of Hands*.

Patricia Leach, Executive Director

Acknowledgments

ART EXHIBITIONS ARE COMPLEX and creative endeavors that rely on teamwork and collaboration. My gratitude foremost to Patricia Leach, executive director of the Whatcom Museum, who shared my enthusiasm for *Show of Hands* and supported the exhibition. I am also grateful for the help and support of the following staff members: Scott Wallin, exhibitions designer; Jan Olson, curator of collections; Curt Mahle, preparator; Patrick Dowling, facilities manager; Judy Frost, finance; Jeff Jewell, photo archives historian; Mary Jo Maute and Elsa Lenz Kothe, educators; Patricia Relay, development officer; Deanna Zipp, museum assistant; Laura Johanson, communications; Todd Warger, security; Kristin Costanza, development associate; Monica Humphry, assistant; and David Miller, artist/preparator.

Several interns and work-study students contributed to the research and related tasks, including Anneke Beach-Garcia, Cory Budden, and Sarah Hanavan, who also carefully compiled the catalogue's bibliography. Thanks to M. Helen Burnham, who is writing her dissertation on Maude Kerns at the Graduate Center of the City University of New York and recommended paintings by the artist to include in the exhibition.

As a newcomer to the region, I consulted many colleagues who helped me establish an initial list of artists to consider: Sarah Clark-Langager, director of the Western Gallery, Western Washington University, and Susan Parke, former director of the Museum of Northwest Art, were the first to offer suggestions on artists to include in the exhibition. Sarah has been the consummate colleague, sharing insights and information with me throughout the process. Chris Bruce, director of the Museum of Art at Washington State University in Pullman, and Jim McDonald, senior program officer at the Paul G. Allen Family Foundation, kindly reviewed my list, as did Greg Kucera, who pointed out the many exhibitions and research projects worldwide devoted to the art of women. He sensed a trend, a new direction of inquiry in which the Pacific Northwest would now be a part.

David F. Martin, independent curator and partner at Martin-Zambito Fine Art, was a vital resource on all matters related to artists from the first half of the twentieth century. He generously shared his well-documented biographies, recommended artists to include in the exhibition, and loaned key works of art that strengthened the show. Alison Stamey and Francine Seders shared artists' catalogues with me, provided help in tracking down work, and loaned several important pieces to the exhibition.

I deeply appreciate the generosity of all the private collectors who agreed to share their artworks with the public: Carol I. Bennett, Nicolette Bromberg, Jane Ellis and Jack Litewka, Susan Grover, David F. Martin and Dominic Zambito, Microsoft Art Collection, Yoshimi Ott, Robert and Shaké Sarkis, Gale and Susann Schwiesow, Pat Scott, Francine Seders, Phil and Mary Serka, and Judy Tobin and Michael Baker. Thanks also to Randall Chase, who graciously

transferred his mother's videotapes into DVD format and helped facilitate the loan of Doris Chase's *Encircled* from the Washington State Convention Center.

The help of curators and registrars who facilitated the loan of artworks from their museum collections was invaluable: Margaret Bullock, curator of collections and exhibitions, and Rock Hushka, curator of contemporary art and Northwest art, Tacoma Art Museum; Judy Sourakli, curator of collections, and Elizabeth Brown, chief curator, Henry Art Gallery, University of Washington; Lynette Miller, head of collections, and Fred Poyner, registrar, Washington State Historical Society; Betsy Bruemmer, collections manager, and Kristin Halunen, registrar, Museum of History and Industry; Andrea Moody, curator, Abby Williams Hill Collection, University of Puget Sound; Lisa Young, curator of collections, Museum of Northwest Art; Pam McClusky, curator of African and Oceanic art, and Lauren Tucker, associate registrar, Seattle Art Museum; Jill Hartz, director, Jean Nattinger, registrar, and Adriane Lafoya, collections manager, Jordan Schnitzer Museum of Art, University of Oregon; and Berit Ness, program coordinator, Washington Art Consortium (WAC).

The staff and directors of art galleries in Seattle and Portland were instrumental in making this exhibition a reality: Elizabeth Leach Gallery, Fetherston Gallery, Friesen Gallery, Froelick Gallery, G. Gibson Gallery, Gordon Woodside/John Braseth Gallery, Grover/Thurston Gallery, Howard House Contemporary Art, James Harris Gallery, Laura Russo Gallery, Linda Hodges Gallery, Lawrimore Project, and PDX Contemporary Art. Sean Harrison, registrar, and Bernie O'Brien, project manager, at Artech also helped facilitate loans of artwork.

To all the staff at Marquand Books who produced this catalogue in record time—Ed Marquand, Adrian Lucia, Jeff Wincapaw, Zach Hooker, Nicole Gelinas, Sara Billups, and Brynn Warriner—thank you for your encouragement, hard work, and beautiful design. I am also grateful to John Pierce, who sensitively edited the text and was a pleasure to work with.

Special thanks to the City of Bellingham, which helped make this catalogue a reality. Its support of the Whatcom Museum is a model for small cities across the country seeking to strengthen both art and community.

I would also like to acknowledge the generous support of the Western States Arts Federation (WESTAF) and the National Endowment for the Arts (NEA) for funding the exhibition and a portion of the accompanying catalogue, which was also supported with a grant from the Washington Art Consortium.

Thank you to all of the participating artists, many of whom answered questions, loaned artworks, and offered support.

Finally to Jyoti Duwadi, who wisely suggested that I never lose sight of the spirit of the women who created these wonderful works of art.

Barbara Matilsky, Curator of Art

9

A Gathering of Women

Barbara Matilsky

SHOW OF HANDS CELEBRATES WOMEN'S CONTRIBUTIONS to the legacy of Northwest art. It coincides with the centennial of women's suffrage in Washington State, a right granted ten years prior to the passage of the Nineteenth Amendment to the United States Constitution. Against the backdrop of this milestone, the exhibition offers a forum for considering women's history and future as contemporary culture continues to redefine traditional gender roles and relationships.

Highlighting a variety of work in all media by artists from Washington, Oregon, and British Columbia, *Show of Hands* reveals a rich tapestry of creativity, from the heroically scaled abstract paintings of Mary Henry to Diem Chau's delicate images embroidered on silk and mounted on porcelain dinnerware. An intergenerational dialogue emerges among the artworks as the exhibition unfolds thematically and chronologically, starting with works from 2010 and moving back to 1880. Whenever possible, two works by each artist are exhibited to show the development of her career. The exhibition also draws on the strength of the Whatcom Museum's collection of Northwest art.

Site-specific wall paintings created for the Lightcatcher passageway introduce a large gallery devoted to works engaged in biomorphic and geometric abstraction. Rooted in prehistoric art, the arts of non-Western cultures, and early modernism, these works confirm abstraction's vital role in expressing the spiritual aspects and formal beauty of life.

Show of Hands also features artists whose approach is more representational and driven by content. Some interpret the figure to convey personal or communal stories, at times conjuring up narratives that reference historical, social, and environmental issues. Many artists find inspiration in Native American art. The heritage of women's handicrafts is given a new twist by contemporary artists who resurrect and reinterpret skills passed down through generations. The final section of the exhibition focuses on landscape, the genre that motivated many of the earliest artists shown to paint a variety of scenes, including mountain panoramas and intimate forest views.

Having arrived recently from the East Coast, I was unaware of the talented mix of artists working in this region. As I learned about its history and the major artists associated with the Northwest school, I became conscious of many "unseen artists," women who exhibited nationally and were highly regarded during their lifetime but have since been forgotten. During my research, I also came across images of works by established artists that excited me. One was of Patti Warashina's *Splash of Reality* (1978), a ceramic sculpture of a woman

splattered with paint and possessed by great freedom sailing through the air on a household iron. The work was unlike anything I had seen before, and the message was compelling. My inquiry kept tugging me in the direction that led to the organization of *Show of Hands*—an effort that demanded a fast and furious learning curve.

Fortunately, I was guided by several excellent exhibitions organized recently that spotlight the artwork of women in Oregon and Washington. David Martin, a partner in Martin-Zambito Fine Art, curated *Pioneer Women Photographers* in 2002 for the Frye Art Museum and *An Enduring Legacy: Women Painters of Washington 1930–2005* for the Whatcom Museum in 2005. Terri Hopkins and Lois Allen organized *Northwest Matriarchs of Modernism* in 2004 for the Art Gym at Marylhurst University and the Northwest Museum of Art. *Show of Hands* builds on the framework of these exhibitions with the hope that it inspires further interest in the subject.

~ ~ ~

One of my first observations as I organized this exhibition was the important contribution that Northwest women have made to the history of abstraction in the United States. In response to the art of pioneering European modernists, they invented a personalized vocabulary in tandem with their counterparts at burgeoning art capitals across the country.

The constructivist movement, pioneered by artists such as Wassily Kandinsky (1866–1944) and László Maholy-Nagy (1895–1946), made a lasting impression on Maude Kerns and Mary Henry, who similarly embraced the spirituality associated with geometric forms. In the true essence of the avant-garde, Doris Chase stretched the boundaries of kinetic art by integrating new technologies into her art making.

More recently, Anne Hirondelle and Victoria Haven have channeled the spirit of constructivism in ways unique to the media in which they work. And innovative practice distinguishes the early sculptures of Elizabeth Sandvig as well as the interpretations of light by Virna Haffer, Ellen Ziegler, and Norie Sato.

Another twentieth-century movement that influenced artists in the Northwest was abstract surrealism, distinguished by its spontaneous, flowing forms that evoke the landscape of dreams and the unconscious. It spawned a visual language that was organic, visceral, and what came to be known as biomorphic. Margaret Tomkins absorbed this freely expressive style that emerged from automatic drawing. Maria Frank Abrams also began her career within the orbit of the movement.

Surrealism informed the work of artists who became known as abstract expressionists. Artists in the exhibition, including Kathleen Gemberling Adkison, Lucinda Parker, Mary Ann Peters, Caryn Friedlander, and Barbara Sternberger, interpret some of the formal qualities pioneered by these artists, adapting them to express their personal relationship to the natural world.

The dynamic paintings of Maude Kerns (1876–1965) are among the most innovative works of abstract art emerging from the region (fig. 1). Inspired by the work of Wassily Kandinsky and Hans Hofmann (1880–1966), the artist exhibited side by side with László Maholy-Nagy and other leading modernists at the Museum of Non-Objective Painting in New York (which became the Solomon R. Guggenheim Museum) in the 1940s. She experimented with geometric compositions that visualize both cosmic and microscopic worlds. Whereas Kandinsky's theosophical beliefs informed the spiritual dimension in his art, Kerns arrived at a similar meditative effect through her faith in Christian Science. Teaching at the University of Oregon, Eugene, for twenty-six years, she disseminated the most current ideas about color theory and abstraction to a generation of artists and educators.

Sally Haley (1908–2007), who arrived in Portland after studying at Yale University, developed a different approach to abstract art. She moved easily between abstraction and representation and was inspired by the work of the Italian proto-surrealist painter Giorgio de Chirico (1888–1978), who juxtaposed strangely disparate objects in stark architectural plazas. Haley created a body of still-life paintings that are similarly eerie and magically realistic. She also flattened walls, doors, and windows into elegant geometric shapes.

The grandly scaled paintings of Mary Henry (1913–2009) underscore the confidence with which the artist expressed her passion for bold colors and hard-edged compositions. Her work reflects her study in 1945 in Chicago at the Institute of Design with László Maholy-Nagy, who came from the groundbreaking Bauhaus school in Germany. Henry was subsequently invited to join the faculty, the first woman to be so recognized, but family responsibilities forced her to relocate to Arkansas. In the 1960s, the artist produced monumental geometric paintings such as *On/Off 8A On/Off 8B* (1967, fig. 2) that find affinities with op (optical) art and postpainterly movements. In contrast to later minimalist artists, Henry embraced the spiritual ideas inherent in the geometries that she continued to interpret throughout her long career.

Doris Chase (1923–2008) was fascinated by circles and their holistic connotation. She translated them into laminated wood sculptures and public artworks in the 1960s (fig. 3). As a pioneering computer, film, and video artist in New York City during the 1970s and 1980s, she often reinterpreted her three-dimensional

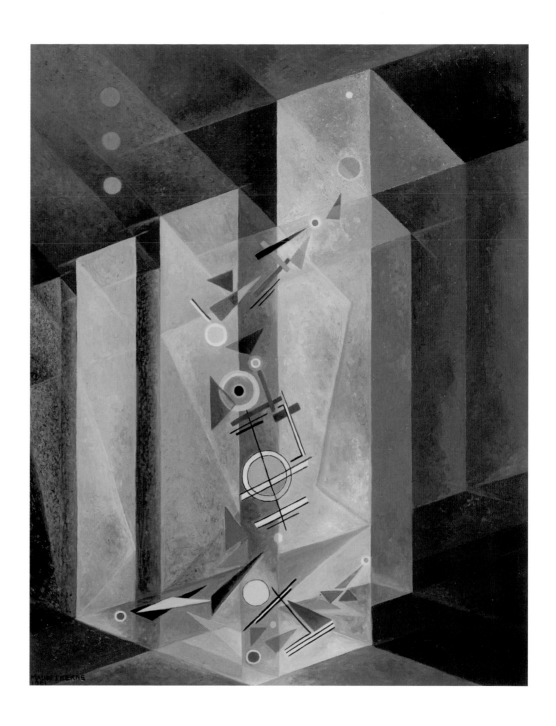

1.
Maude Kerns
Composition #85 (In and Out of Space), 1951
Oil on canvas
28 × 22 inches

2.
Mary Henry
On/Off 8A On/Off 8B, 1967
Acrylic on canvas
Each: 60 × 60 inches

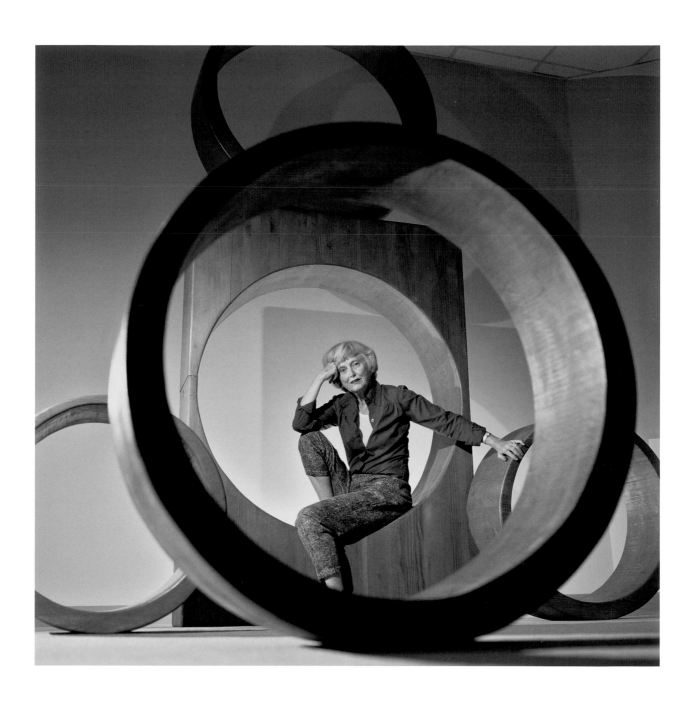

3.
Doris Chase
Encircled, 1968
Laminated fir
Height: 10 feet

4.
Anne Hirondelle
Tumble #10, 2009
Unglazed stoneware and paint
10 × 9½ × 7 inches

forms and fused them with choreographic movements to create what she called "video dance." Chase envisioned art as a "bridge to awareness," encouraging viewers to rearrange and activate her kinetic works. The artist's passion for change motivated her diverse achievements. Toward the end of her career, Chase wrote and directed a series of theatrical productions that centered on monologues by women. Based on the "experiences that shape a woman's life," these works, including *Table for One* (1985), starring Geraldine Page, were screened nationally.[1]

The geometry of the constructivist movement also informs Anne Hirondelle's (b. 1944) ceramic sculpture *Tumble #10* (2009), which is composed of concentric circles (fig. 4). The artist notches the forms to cleverly prevent tumbling. Her bright colors—often primary in hue—dramatically contrast with the white, unglazed stoneware. These recent works differ from the artist's earlier vessel-based pieces, such as *Dance Diptych* (1991), two rhyming pitchers with curved handles that nestle into each other.

During the late 1930s and 1940s, Margaret Tomkins (1916–2002) established a national reputation as an abstract surrealist painter. Untitled (1949, fig. 5), defined by earth tones, hauntingly evokes human and landscape forms that

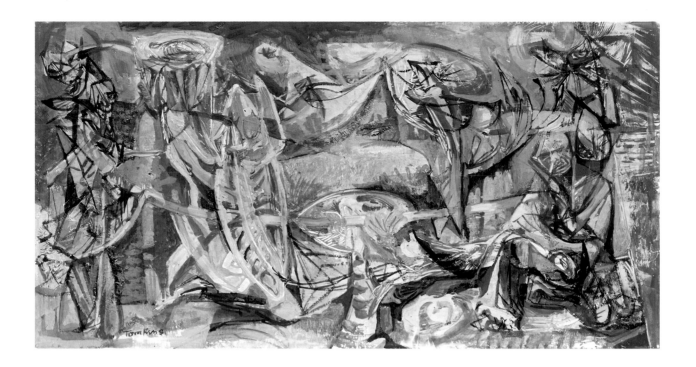

5.
Margaret Tomkins
Untitled, 1949
Oil on canvas
14 × 26 inches

"search the emotional, psychic, and physical tensions in the metamorphosis of nature and man as one."[2] Beginning in the 1960s, the artist created large expressionist paintings such as *Twice Sun White* (1963), which is made up of interlocking shapes in lighter colors applied with a palette knife. Her marriage to James FitzGerald (1910–1973), a prominent sculptor, stimulated her own body of three-dimensional art using the lost-wax method. Living in seclusion on Lopez Island until her death, Tomkins layered her later canvases, such as *Quantum* (1979), with radiant shafts of pastel colors that reflect the artist's lifelong quest to balance internal and exterior realities.

The interplay between nature and abstraction informs the work of many artists, including the pioneering photographer Ella McBride (1862–1965). Although representational in subject matter, the artist's photograph from the 1920s of a vase filled with nasturtiums anticipates later, more abstract interpretations of the natural world. She positions her still life at the far edge of the composition, a placement inspired by Japanese prints, leaving a large, undefined, luminous abstract space. McBride, who worked with Edward Curtis in his photography studio and later opened her own business in 1917, exhibited internationally in the 1920s.

Although Kathleen Gemberling Adkison (b. 1920) studied with Mark Tobey (1890–1976), she did not pursue his signature calligraphic style of abstraction. Instead, the artist built up her canvases, which were placed on the floor, with broad strokes and sometimes splattered paint. In *Fire Rock* (1981), one in a series of oil paintings on this subject, the hot colors and molten quality of the surface represent Adkison's desire to express the "insistent life-force of energy expressed by nature."[3]

Lucinda Parker (b. 1942), known for her virtuoso paintings and passion for process, creates both modestly scaled and large commissioned works for public spaces that reveal her intimate relationship to the natural world. In *Snags* (2006), tree-trunk-like forms suffused in golden light are born from the artist's imagination and inspired by hikes in the woods (fig. 6). Parker often uses a spatula rather than a brush to apply heavy impasto passages of acrylic paint that coalesce into expressive architectural and organic forms.

This duality in subject characterizes Elizabeth Sandvig's (b. 1937) *Broken Columns* (early 1970s), created from wire mesh screens that become animated by filtering light (fig. 7). The artist, known more widely now as a painter, experimented with an array of materials to create innovative sculptures in the 1970s, the same period when Alan Saret (b. 1944) began working with wire in New York City. According to Sandvig:

> For the first half of my career, my work dealt with the transitory and fragile qualities of nature. Using materials that emphasized a sense of layered transparency, I attempted to create a shifting visual energy effect by light and position. When my work threatened to disappear into fragility, I turned to drawing vigorously with oil sticks and to painting.[4]

Mary Ann Peters (b. 1949) has been exhibiting paintings and drawings since the 1980s when she began deciphering the lost worlds of archeology and dreams. The part-fact, part-fiction quality of her visions are expressed through a distinctive, lyrical style. In *In an instant . . . a delicate balance* (2006), the artist's spontaneous lines and delicate washes of colors create a garden of abstract forms that reflect her interpretation of environmental disintegration. As Peters explains:

> The work was derived from current events but those tied to the land and the power of place. I started thinking about how we reconstruct the mental picture of a place that has been destroyed or irrevocably

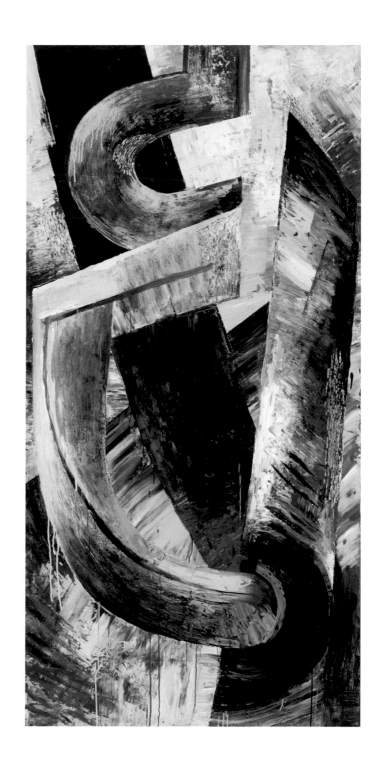

6.
Lucinda Parker
Snags, 2006
Acrylic on canvas
85 × 42 inches

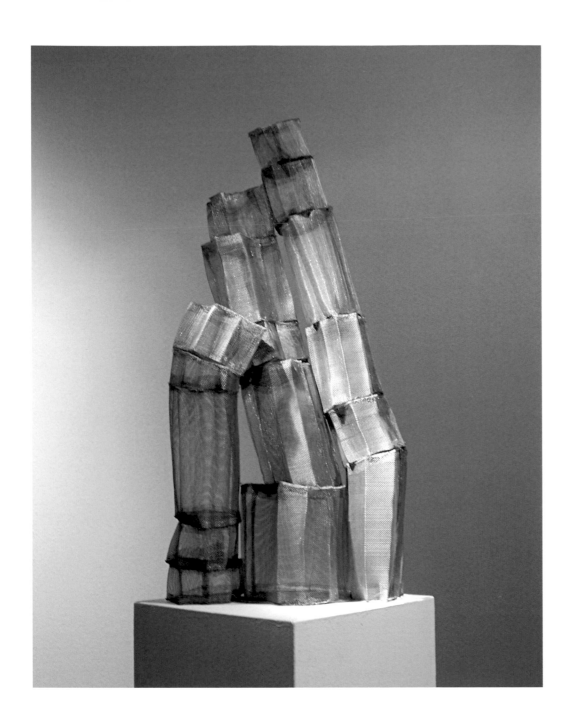

7.
Elizabeth Sandvig
Broken Columns, early 1970s
Screen mesh
32 × 15 × 7 inches

changed. I settled on trying to draw that juncture or instant, in the moment of its destruction, that a site or building or landscape becomes the sum of its parts, which in observation is abstract and possibly beautiful. It's suspended animation, really.[5]

The watery environment of the Pacific Northwest has been a central focus in Caryn Friedlander's (b. 1955) paintings for many years. It provides an opportunity to integrate gestural brushstrokes with the flow of nature. In *North Shore* (2007), the artist presents the remnants of infrastructure—a pier that terminates abruptly and wood pilings subsumed by the action of waves. Friedlander, who earned master's degrees in Asian art history and fine arts at the University of Washington, finds inspiration in Chinese calligraphy and landscape and in Western artists such as Henri Matisse (1869–1954) and Joan Mitchell (1925–1992). About her work, the artist says, "I could convince myself that the work is about water, but that's an excuse; foremost I am an inveterate mark maker."[6]

The abstract paintings of Barbara Sternberger (b. 1957) depend on lush passages of color that build sensual surfaces. In *Immediate* (2008), the artist defines interlocking forms ascending from the bottom edge of the canvas. A black flourish of paint moves abruptly into the entwined pattern, perhaps giving rise to the title. Sternberger presents this "drama" against an atmospheric field of light-filled brushstrokes. The artist describes her intention this way:

> When I begin a painting, I begin a new relationship whose content is revealed in the process of its making. Its subject matter doesn't come from the immediate external world of objects but, rather, gradually evolves from an internal vision generated from experience.[7]

Recognized nationally for her unique body of camera-less photographs, Virna Haffer (1899–1974) interprets aspects of nature through representational and abstract prints. She authored a seminal text, *Making Photograms: The Creative Process of Painting with Light,* that is still referenced today.[8] For *Abstract #15* (c. 1960), the artist placed objects on photographic paper and exposed them to light to capture the texture of seeds and grasses. Contrasting patterns of light and dark animate the surface to evoke the process of regeneration. A darker pessimism that reflects her concern for the fate of the environment was also expressed in a harrowing series of apocalyptic photograms.

Ellen Ziegler (b. 1949) is also fascinated by the effects of light, which she interprets in three-dimensional mirrored drawings. Her abstract compositions, based on the tangible interplay of light and shadow, appear on the wall as if by magic. According to the artist, these works "evoke states of disorientation,

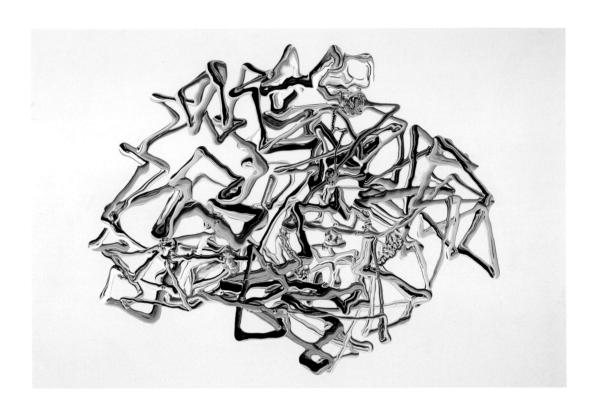

hallucination, and a peculiar wonder." The title of this series, *Hypnagogue*, references the period between waking and sleeping called the "hypnagogic state."[9]

Margie Livingston (b. 1953) and Victoria Haven (b. 1964) designed site-specific paintings for the Lightcatcher passageway that are intriguingly similar yet stylistically distinct (figs. 8 and 9). Both artists eliminated the canvas support and revel in the application of line and color to the wall. Livingston's paintings are playfully expressive, while Haven's works are cerebral and more structured.

In her studio, Livingston created four works in a series titled *Angle, Drizzle, and Dot*. These are loopy, spontaneous compositions of acrylic paint made by pouring colors that exist independently as texture. Haven presents a folding and unfurling puzzle of intersecting lines of color that establishes perspective, creating a focal point at the entrance to the galleries.

Maria Frank Abrams (b. 1924) first began painting colorful, amoeboid forms swirling in undefined spaces after graduating from the University of Washington in 1951. Her later, more geometric compositions, such as *Untitled* (1977), defined in graphite by horizontal planes, reflect the landscape and light of the Pacific Northwest. Abrams survived the Holocaust, and art and nature have renewed

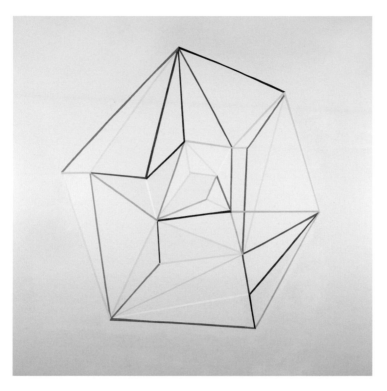

the artist's spirit: "It was very consoling, like a healing process. In my work, I began creating things that were harmonious and peaceful."[10]

An emphasis on horizontality characterizes the finely modulated paintings of Agnes Martin (1912–2004). In Untitled (1965)—a schematic rendition of her larger works—pencil lines band across a small sheet of paper. Martin was a celebrated player in the art scenes of New York City and Taos, New Mexico, but she began her training at Western Washington University in Bellingham. The meditative nature of her grids stemmed from a belief in the spiritual qualities inherent to abstraction, yet ironically they became associated with the reductive character of minimalist art that eschewed meaning, content, or emotion.

A linear definition of space imbued with a Zen-like spirit characterizes *Paused Field* (1979), a mixed-media drawing by Norie Sato (b. 1949), who is recognized as one of the Northwest's leading video and public artists. Out of a white field inspired by the snow and phosphorescence emitted from television sets, the artist conjures a single horizontal band defined by subtle inflections of rainbow-colored pencil lines. Delicate touches of color edged along the bottom of the thick handmade paper invite close viewing.

Lauri Chambers (b. 1951) interprets the atmospheric qualities of white paint applied to Masonite by using scratches and contrasting black, fanlike forms with curving lines. The artist writes that "Content is revealed by process. . . . To understand my work it must simply be looked at. I want the encounter to be very, very quiet."[11]

Elizabeth Jameson's (b. 1962) interpretation of abstraction intersects with her research into costume history and clothing worn by people in hazardous occupations. In *Forecasting Queen* (2009), the artist marries abstract and figurative art in a startling comment on fear and war (fig. 10). A medieval woman wearing a gas mask and a geometrically patterned garment looks out at the viewer, who is both repelled and attracted to the work through its velvety, pastel texture. Jameson writes:

> I investigate our attempts to protect ourselves from fear and the effects
> of these excessive efforts upon our lives through a series of objects
> and drawings that use restrictive and insulating garments as an icono-
> graphic metaphor for self-repression.[12]

Artists interested in conveying messages, often through storytelling and narratives, have developed a variety of fresh approaches and styles to communicate their ideas. Artists reference history (Marita Dingus), autobiography (Faye Jones and Barbara Earl Jones), interactions between nature and culture (Claire Cowie and Elizabeth Sandvig), issues related to identity and relationships (Patti Warashina), as well as more mysterious or dreamlike meditations on reality (Viola Patterson, Gwendolyn Knight, Imogen Cunningham, Marsha Burns, and Margot Quan Knight).

Fay Jones (b. 1936) and her funky, jazzy figures, which loom large on the tableau of life, have charmed Northwest audiences since the 1970s. Often humorous and theatrical, her works reflect a passion for literature and interpreting memories and stories. In an early work, *Crows, Scarecrows* (1974), the artist depicts a menacing landscape of black birds and frightening man-made props that contrasts with the drawing's miniature, fairy-tale-like quality. Later works, like *Loss* (1991), assume a larger, more epic but also abstract presence. The looming heads of two men and a woman, silhouetted in black, suggest a drama of relationships enacted against a mountain peak. The perforated patterns in the paper and layered collage elements add to the mystery of what transpires here.

Elizabeth Sandvig's *Peaceable Kingdom I* (2003) interprets the work of Edward Hicks (1780–1849), a Quaker minister who painted a series with the

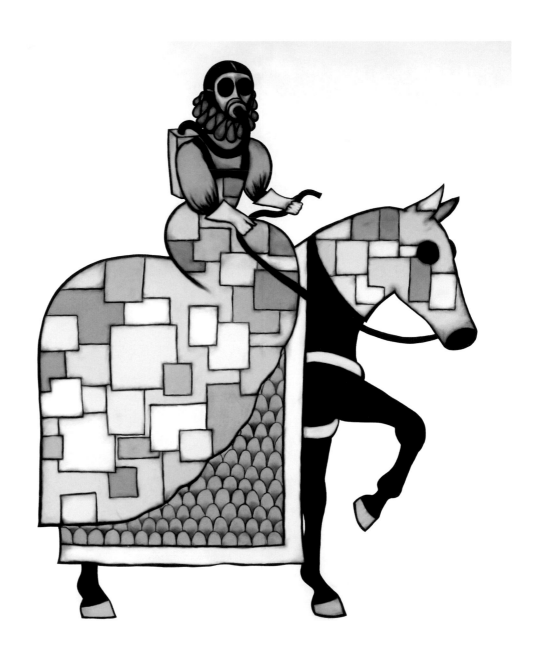

10.
Elizabeth Jameson
Forecasting Queen, 2009
Charcoal and pastel on paper
100 × 84 inches

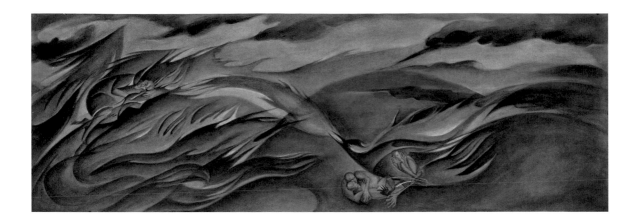

11.
Barbara Earl Thomas
A Fire in the Landscape, 2002
Tempera on paper
21½ × 48¼ inches (framed)

same name. Synthesizing Hicks's folklike style with a Matissean joie de vivre to emphasize bright colors and simplified lines, the artist creates a painting that embodies nature's harmony.

The collision between nature and civilization resonates in Claire Cowie's (b. 1975) *Rhinoscape* (2006), her large-scale sculpture of a white rhinoceros dripping with paint. The artist's interpretation is playful, but it touches on insidious events as she references the true story of Clara, a white rhino captured in South Asia and exhibited in European capitals during the eighteenth century. Cowie poignantly calls into question humanity's relationship with other animals by assembling a small village on the animal's back.

Biblical overtones are present in the artworks of Barbara Earl Thomas (b. 1948), which often reflect her personal history. In earlier, more figurative tempera paintings, such as *A Man Cleaning His Fish* (1987), the artist evokes the spirit of her father and family who migrated from the South to the Northwest in the 1940s. Their love of fishing eased the trauma of relocation. In later paintings, such as *A Fire in the Landscape* (2002, fig. 11), recumbent figures and flamelike birds are dwarfed by swirling landscapes that merge sea and sky. This apocalyptic interpretation of the fate of the environment also personifies the inherent forces of nature that claimed the life of her parents, who tragically drowned while fishing in 1988.

Patti Warashina (b. 1940) is nationally recognized as one of the leading ceramic artists practicing today. She has been exhibiting her work since the 1970s, when she began interpreting the ceramic medium to comment on issues related to identity and gender. Humor and technical virtuosity define works such as *Diamond in the Rough* (1988), a narrative of marital dysfunction communicated through the interaction of partial male and female figures

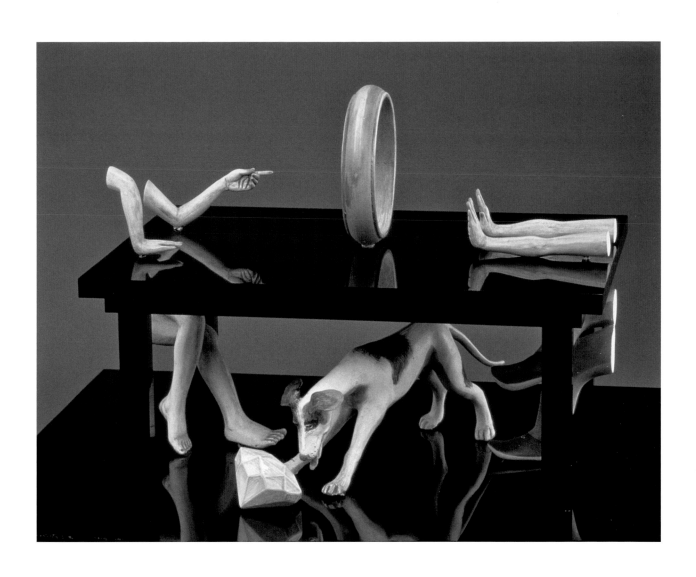

12.
Patti Warashina
Diamond in the Rough, 1988
Fired ceramic white ware with under glazes
10½ × 18¾ × 14⅞ inches

(fig. 12). The comedic drama unfolds over the dinner table, where a giant wedding band is balanced between the two protagonists. The view below reveals a dog, symbol of fidelity, who sniffs a diamond fallen from its setting. Warashina has recently begun casting in bronze. In *Bonded Flight* (2006), the artist presents a stylized bust of an adolescent girl with a bird perched on her head, each looking in a different direction. The ambiguous title and the relationship between the girl and the bird pose questions about independence, safety, and their associated states of mind.

A more understated narrative can be gleaned from *Untitled* (1954), a painting by Viola Patterson (1898–1984) that offers a quiet peek into a veranda where complex patterns dominate the image of a mother and child resting. The artist weaves together a Parisian-style lushness à la Édouard Vuillard (1868–1940), who similarly merged interior and exterior spaces. Patterson's art flourished as she interpreted the modern artworks she experienced during her European travels and while teaching at the University of Washington's art department. Her marriage to Ambrose Patterson, her art professor, who exhibited with the fauvists in Paris in 1905, and her friendship with Walter Isaacs, chair of the art department, encouraged the artist's personal style. In her later works, she embraced a more nonobjective abstraction by painting bold gestural works in a similarly restricted palette. The artist owned Emily Carr's expressive landscape painting (c. 1920) included in *Show of Hands.*

In *Mask IV* (1988), Gwendolyn Knight (1913–2005) updates the language of cubism to reveal a mysterious head that reflects both African art and Picasso's interpretation of it. After attending Howard University and then studying with the sculptor Augusta Savage (1892–1962) in Harlem, she married the artist Jacob Lawrence, who developed his own style of cubism to narrate stories of African-American history. They settled in Seattle in 1971 after Lawrence began teaching at the University of Washington. Knight received recognition for her work when she began exhibiting at the Francine Seders Gallery. In 2003, when she was eighty years old, her career was surveyed at the Tacoma Art Museum.

Sur face (paper) (2009) is one in a series of videos by Margot Quan Knight (b. 1977) that feature the artist. In this work she makes a mask in less than a minute by pressing a simple sheet of paper into her face. In another video in the series, *Sur face (bubbles)* (2009), she blows bubbles to obscure and then reveal herself. These humorous, often beautiful self-portraits reflect the artist's interest in process and experimentation. As the artist writes:

> *Sur face* is a series of video experiments that I developed during a residency at 911 Seattle Media Arts Center. The short videos examine the

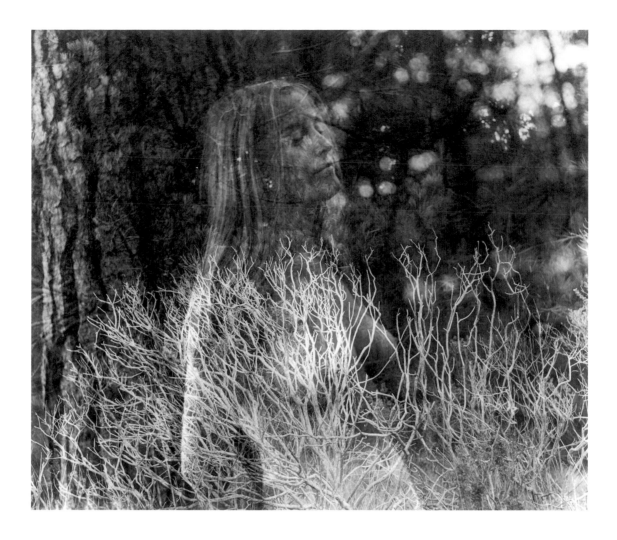

13.
Imogen Cunningham
Dream Walking, 1968
Gelatin silver print
9½ × 10¾ inches

relationship between an image and its source (in this case my face), and the relationship between an image and the surface on which it appears. The surface, so necessary for the image's existence, seems both fragile and impenetrable, a barrier and an opportunity.[13]

Although Imogen Cunningham (1883–1976) garnered international recognition for her abstract and close-up photographs of flowers and plants, such as *Flax* (c. 1920), she was interested in portraying every aspect of life: dancers practicing for a performance at Mills College (1929), the stark imagery of ventilators on top of a building (1934), a humorous look at nuns experiencing an exhibition of Alexander Calder's mobiles (1953), and a civil-rights march in 1963. Her *Dream Walking* (1968), a double exposure of a nude woman blending into nature, recalls

her earlier romantic, pictorialist style (fig. 13). It alludes to the spirit of woman as Earth goddess, an idea that was popularized at this time. Cunningham once remarked, "Perhaps my taste lies somewhere between reality and dreamland."[14]

By contrast, the untitled nude (1978) by Marsha Burns (b. 1945) grows out of her interest in structure and geometry and is illuminated by strong contrasts of light and shadow. The androgynous figure, seen from behind with only a slight hint of profile, is a study of athletic prowess: ripples of muscle and bony angles are spot lit and abstractly beautiful.

A personal interpretation of history by Marita Dingus (b. 1956) emerges in *200 Women of African Descent* (1994), which was inspired by the artist's visit to Elmina Castle in Ghana in 1992. There Dingus visited the dungeons where Africans were imprisoned, often two hundred in one small room, before their long journey by sea to the Americas. The artist pays homage to these people by sewing two hundred dolls—minus the heads that indicate individuality—in an installation that conveys the sheer multitude of slavery's victims. While making reference to the past, Dingus presents this work as a meditation on her ancestry and a creative outlet through which to process her harrowing memories.

In most global cultures, women's handicrafts are essential to survival. Since the 1980s, artists such as Sherry Markovitz and Sheila Klein have become increasingly attuned to the potential of sewing, knitting, beading, crocheting, and other traditional skills to translate contemporary ideas. The variety of innovative forms emerging from just one approach was recently surveyed in *Radical Lace and Subversive Knitting,* an exhibition held in 2007 at the Museum of Arts and Design in New York.

Sherry Markovitz (b. 1947) has been making exquisitely beaded sculptures since the early 1980s. Her animals, figures, and abstract forms reflect a childlike sense of wonder and an inquisitive knowledge of world culture. In 2004, the artist was commissioned to create a sculpture of a young ewe (fig. 14). The only requirement was that she transform her materials into something stunningly beautiful. Using shimmering beads, the artist made *Mourning You/Morning Ewe* (2007), which looks back to paintings of sheep the artist made more than thirty years earlier. Markovitz alludes to hope and renewal as she weaves together an image of vitality with a title that hints at death. For the artist, "The image of the sheep evoked many ideas for me about warmth, peace, beauty, history and nomadic culture."[15]

Diem Chau (b. 1979) creates unusual relief sculptures by embroidering images on silk mounted on ordinary porcelain dinnerware. The intimate scale of these household items combined with evocative details of the human figure

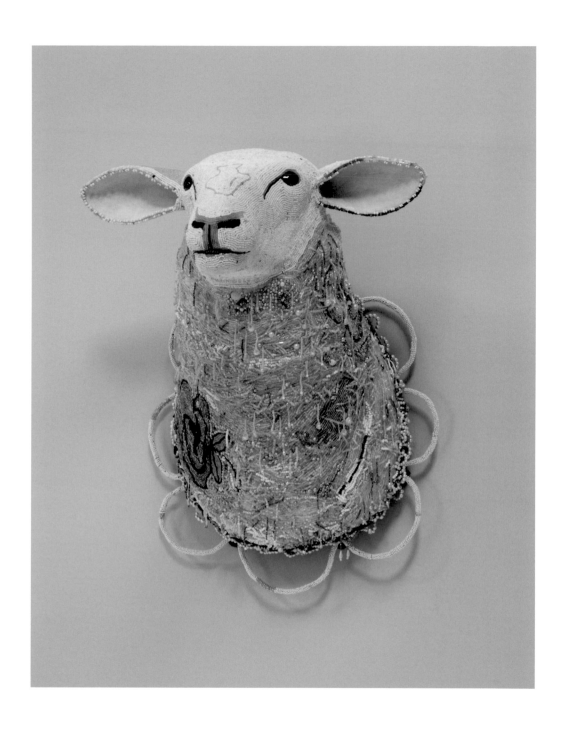

14.
Sherry Markovitz
Mourning You/Morning Ewe, 2007
Mixed media
19 × 15 × 17 inches

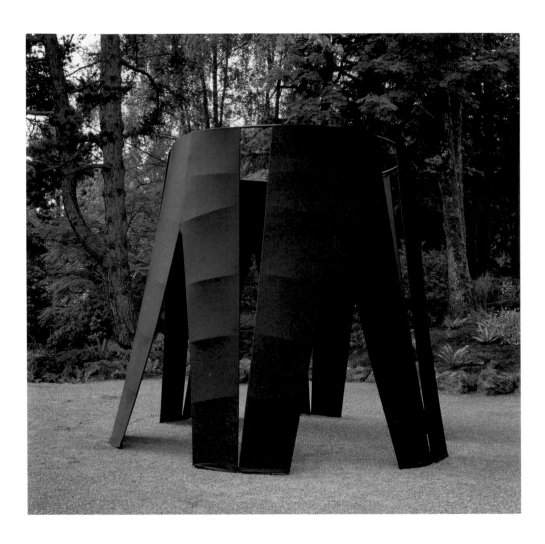

15.
Sheila Klein
Stand, 2000
Nylon, Lycra, spandex, and steel
13 × 13 × 9 feet

—hands, a half-figure of a young girl with braids streaming down her back—provides traces of childhood stories or memories.

Maki Tamura (b. 1973) cuts paper into elaborate doilylike patterns to serve as frames and background for a mysterious tableau. *Moonlight Spell* (2008) contains pictures within a picture, watercolors evocative of eighteenth- and nineteenth-century heraldic emblems and zoological illustrations. Dreams, stories, and memories fuse in this work.

Sheila Klein (b. 1952)—recognized nationally for her public artworks, objects made from fabric, and crocheted sculptural reliefs—works in the space between art, theater, and architecture. For the Lightcatcher courtyard, the artist sited *Stand* (2000), a thirteen-foot-high, self-supporting sculpture constructed from nylon Lycra that takes the shape of gigantic pairs of men's black stretch

pants (fig. 15). Wittily conflating clothing and architecture, the artist invites visitors to walk through the legs of this work. In *Textile Wallah* (2009), which drapes dramatically from the ceiling, Klein translates Indian architecture from Jaipur into ornate, crocheted patterns that form three life-sized arching palace portals.

Gail Tremblay (b. 1945) is an artist, writer, and activist of Onondaga and Mi'kmaq ancestry who has lived in Washington for more than twenty years. She currently teaches at Evergreen State College. Her recent series of works—baskets made from 35mm and 16mm film, with titles such as *An Iroquois Dreams That the Tribes of the Middle East Will Take the Message of Deganawida to Heart and Make Peace* (2009)—reference political global issues (fig. 16). The artists writes:

> I enjoyed the notion of recycling film and gaining control over a medium that had historically been used by both Hollywood and documentary filmmakers to stereotype American Indians. I relished the irony of making film take on the traditional fancy stitch patterns of our ash splint and sweetgrass baskets.[16]

The strong influence of Native American culture can also be seen in the works of Helmi Juvonen, Ebba Rapp, and Myra Wiggins, artists who were inspired by masks, petroglyphs, and totem poles. Likewise, native peoples and rituals have been portrayed with an eye for preserving a record of what was perceived as a vanishing way of life by artists such as Ruth Kelsey. Louise Crow was captivated by the formal beauty and abstract aspects of native culture—its colors and textures—which confirmed directions in her own art. Susan Point invokes Native American iconography and spirituality to propose a more balanced relationship between humans and the environment, and Marie Watt creates totemic-like columns that highlight the significance of blankets in Native American culture.

Louise Crow (1891–1968) lived in Seattle and spent time in Sante Fe, New Mexico, where she became acquainted with the artist Marsden Hartley (1877–1943), who wrote highly of her 1919 exhibition at the Museum of Fine Art, Santa Fe. *Eagle Dance at San Ildefonso* (1919), painted with bold colors and photographic clarity, combines figures, architecture, and landscape in a single powerful work (fig. 17). Using dramatic shadows and unusual compositional cropping that enhance the painting's theatrical effect, Crow interpreted a ritual and sealed it in timelessness. David Martin, who has done extensive research on the artist, discovered that this painting was the first modernist work by a Seattle artist to be exhibited in a major international salon, the Autumn Salon in Paris

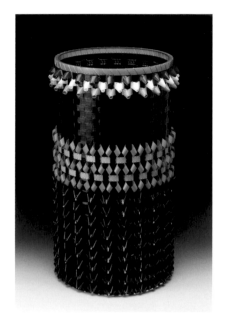

16.
Gail Tremblay
An Iroquois Dreams That the Tribes of the Middle East Will Take the Message of Deganawida to Heart and Make Peace, 2009
16mm film, leader, rayon cord, and thread
24 × 14 × 14 inches

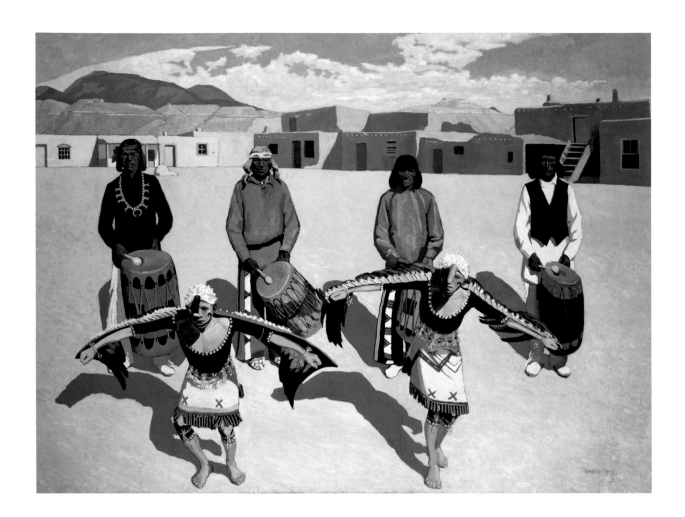

17.
Louise Crow
Eagle Dance at San Ildefonso, 1919
Oil on canvas
71½ × 95½ inches

in 1921. The artist, who is also known for her portraits, exhibited at major museums around the United States during her lifetime.

Helmi Dagmar Juvonen (1903–1985) is one of the Northwest's most recognized artists. Tragically, she is also known as the artist who, obsessed by Mark Tobey and later diagnosed as manic-depressive, spent twenty-six years in an asylum. Despite her situation, the artist's creativity flourished, stimulated by her avid study of native Northwest art. Initially, as in *Northwest Coast Mask* (c. 1947), Juvonen documented brightly colored carved masks and totem poles that retain the power of their original makers. Toward the end of her life, the artist's drawing style became freer as she defined the iconography of native art more abstractly in drawings like *Petroglyph* (1967–68). According to the artist Wes Wehr, a friend of Juvonen, she was invited to attend Native American rituals,

which she often sketched, and was affectionately called "Northern Light," a reference to her Scandinavian heritage.

Ruth Kelsey (1905–2000), who taught at Western Washington University from 1948 to 1972, was a much-admired arts professor. Among her most important works of art are portraits, dating from 1938 to 1942, of Native Americans living in north-central Washington (fig. 18). She was invited to join the Nespelem Art Colony established by Washington State College (now Washington State University) to document Native American people and the culture of the Colville Confederated Tribes. Clyfford Still (1904–1980), a professor at WSC and a prominent abstract expressionist, was one of the colony's instructors. In the spirit of the early American artist George Catlin (1796–1872), who embarked on a similar mission, Kelsey painted sensitive portraits of women and men such as *Chief Red Star* (1941). Using broad brushstrokes, the artist expressively captures the spirit of the sitter, a regal and compassionate man with a yearning expression. After completing fifty paintings during three summers, Kelsey wrote:

> Our good relations with the tribal members [were] probably because of mutual admiration. Chief Red Star allowed us to paint his portrait several times. We would walk past his house on our way to class and often he or some members of his family were outdoors, so we had an opportunity to greet them or stop for a visit. He and his family became our good friends, although all of the Indians I met were friendly.[17]

Ebba Rapp (1909–1985) was a multifaceted artist who painted, made ceramic sculpture, exhibited her work regularly, and taught three-dimensional design at the Cornish School. Her haunting *Totem of Rumor* (c. 1950, fig. 19) provides multiple perspectives into the artist's work: the impact of Native American culture, her studies with noted Russian artist Alexander Archipenko (1887–1964) at the University of Washington, and the pull of surrealism, which stimulated artists to visualize the unconscious.

Myra Albert Wiggins (1869–1956) created a beautifully composed photograph of a totem pole hovering over the Alaskan landscape in the 1890s (fig. 20). The work is both an ethnographic record and a stirring interpretation of the union between nature and culture. The artist, an internationally recognized photographer who exhibited at major museums in the United States, was invited by Alfred Stieglitz in 1903 to join the Photo-Secession. After her solo show in 1928 at the Seattle Fine Arts Society (which became the Seattle Art

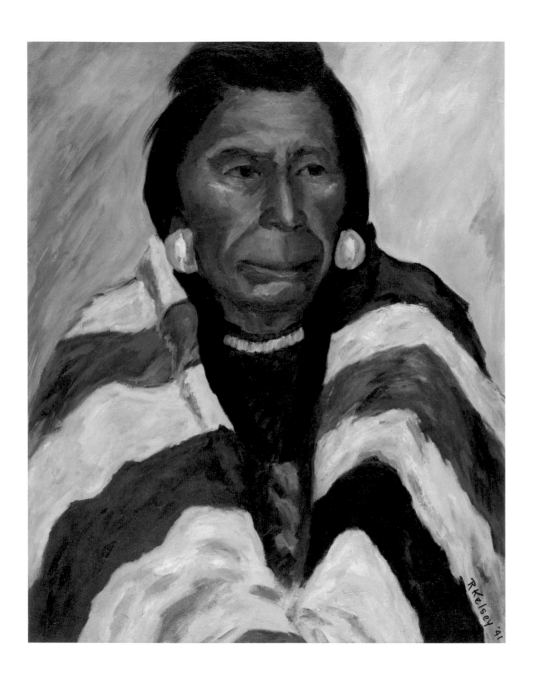

18.
Ruth Kelsey
Chief Red Star, 1941
Oil on canvas
34⅜ × 28¾ inches (framed)

Museum), Wiggins turned her attention to painting and cofounded Women Painters of Washington in 1930.

In *River Worn by Time* (2002), Susan Point (b. 1952) creates a totemic composition in which fish and water seamlessly merge. The print's sinuous abstract patterning suggests the art of weaving. The artist began her career as a jeweler and later became actively engaged in her native Coast Salish culture. Since the 1980s she has reinterpreted traditional images to communicate messages of environmental and cultural preservation. As the artist has written, "The task of my generation is to remember all that was taught, and pass that knowledge and wisdom on to our children."[18]

In *Blanket Stories: Ladder, Great Registry, Oregon Trail, Long Haul and All My Relations* (2008), Marie Watt (b. 1967) presents a sentinel figure or totem, conveyed by stacking wool blankets of various colors and patterns into a towering composition. The artist explores the history, symbolism, and personal stories associated with blankets, functional and often ceremonial objects in Native American culture. The work's array of colors, sculptural folds, and monumentality commands the gallery space. Watt also interprets her blanket columns in more traditional materials by carving pieces of salvaged cedar into Brancusi-like sculptures.

The genre of landscape painting attracted early women artists in the Northwest. The wilderness as well as natural areas closer to home inspired artists such as Harriet Foster Beecher, Abby Williams Hill, Eliza Barchus, Anna Gellenbeck, and Margaret Camfferman, who were captivated by the coastal and mountain light. The changing landscape, its more developed and sometimes insidious side, also catalyzed the works of Zama Vanessa Helder and Yvonne Twining Humber. The drawings and paintings of both artists reflect the magical-realist side of surrealism popularized by Salvador Dalí. This direction also provided artists such as Blanche Morgan Losey with an opportunity to represent psychological landscapes. More recently, Karin Helmich has combined a realistic style of painting with her own interpretation of nature's mysteries.

In 1881, Harriet Foster Beecher (1854–1915) became the first professional artist to establish a studio in Seattle, which she called the Fine Arts Studio. Using oil and watercolor, she painted the semipermanent fishing outposts and activities of Clallam and Makah peoples along the shores near Port Townsend. In *Alameda* (1880), the earliest work in the exhibition, Beecher freely paints the changing atmosphere of the Northwest with an impressive command of naturalistic effects (fig. 21). The colors and luminosity of her watercolors, which were painted en plein air, are reminiscent of the topographical landscapes of J. M. W.

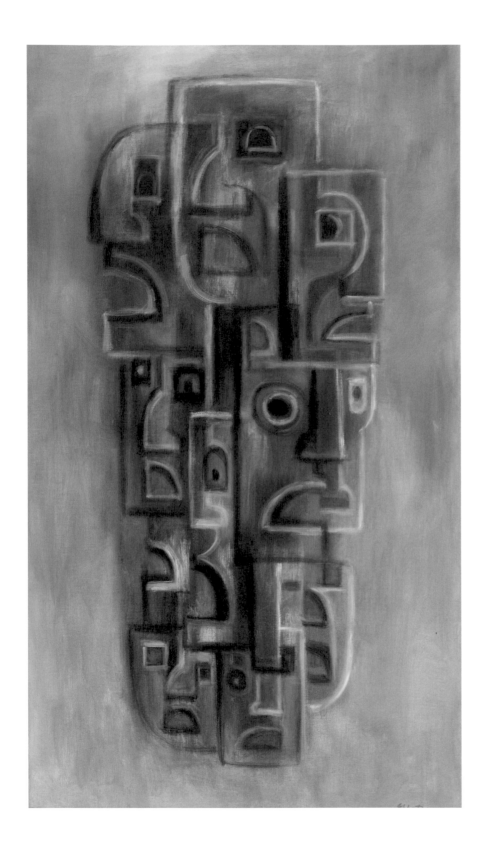

19.
Ebba Rapp
Totem of Rumor, c. 1950
Oil on canvas
51¾ × 31 inches

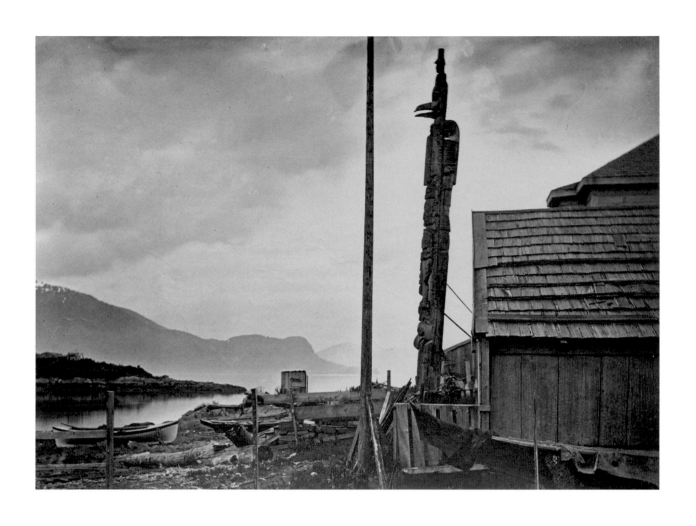

20.
Myra Albert Wiggins
Alaska, c. 1899
Platinum print
4 × 5 inches

21.
Harriet Foster Beecher
Alameda, October 19, 1880
Oil on paper
20 × 26 inches (framed)

Turner (1775–1851). Beecher also established a reputation as an important portrait artist and received commissions from many prominent citizens, such as the early pioneer Ezra Meeker (1830–1928), whose portrait from 1914 is in the Museum of History and Industry in Seattle.

Abby Williams Hill (1861–1943) painted the sublime vistas of the American west, including many of its iconic monuments—Yellowstone, the Grand Canyon, Bryce Canyon, and the Rocky Mountains. She was commissioned by the Great Northern Railway in 1903 and the Northern Pacific Railway over three consecutive years (1904–1906) to travel the routes carved through the wilderness, and she camped with her four children in remote places to access the wonders of nature. *Horseshoe Basin* (1903), a panoramic, birds-eye view of a glacial cirque in the Cascades, embodies the sublimity that characterizes the international legacy of nineteenth-century landscape painting (fig. 22). In 1926, Hill traveled to the Canadian Rockies and captured the emerald green waters of Lake Louise in a looser, more painterly style. Although the artist's works were exhibited in

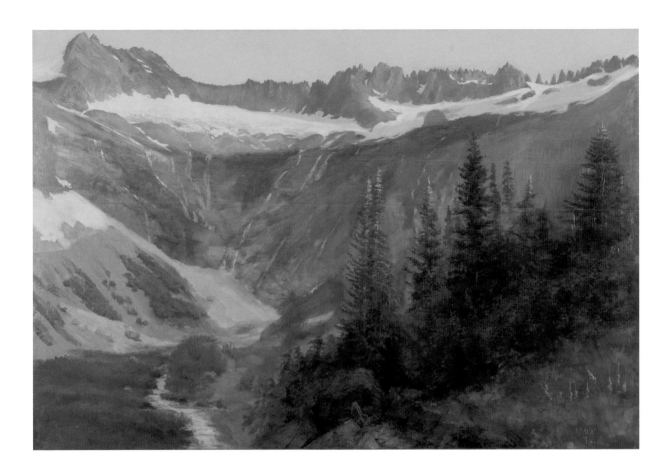

22.
Abby Williams Hill
Horseshoe Basin, 1903
Oil on canvas
41⅛ × 28⅜₁₆ inches

expositions across the country and received favorable notices in the press, her paintings were soon forgotten. A comprehensive collection of her work is preserved at the University of Puget Sound.

Eliza Barchus (1857–1959) was celebrated during her long career and received the distinct recognition as "the Oregon Artist" in 1971 by the state legislature. She supported herself by selling her artworks in large numbers through three commercial outlets, sometimes repeating motifs in the way that Sydney Laurence (1865–1940) was apt to do. Barchus's works were purchased by notable historical figures, including Theodore Roosevelt and Woodrow Wilson. The Whatcom Museum's untitled painting (c. 1890) of a glaciated mountain peak is one of her largest landscapes, and its ornate gilt frame attests to the importance that the collector accorded this work. In 1935, Barchus discontinued painting in response to her failing vision.

Biographical information about Anna Gellenbeck (1883–1948) remains scarce, but there is little doubt about the artist's ambition and creative power when

23.
Anna Gellenbeck
Richardson Highway, Alaska, 1944
Oil on canvas
37⅜ × 35¹¹⁄₁₆ inches

one views *Richardson Highway, Alaska* (1944, fig. 23). The work is as much a skyscape as a depiction of sweeping tundra, and in it the artist focuses her composition on an abstract cloud formation exploding with energy. In 1934 the artist was commissioned to create twenty paintings "showing the beautiful coloring, unusual geological formations and striking panoramas of the giant Grand coulee." According to a newspaper article archived in the Washington State University Wallis and Marilyn Kimble Northwest History Database, these paintings were slated to tour the United States. Further research might uncover the whereabouts of these artworks.[19]

Margaret Camfferman (1881–1964) was Gellenbeck's contemporary, but she approached landscape painting quite differently. Her untitled painting from 1935 (fig. 24), the same year that the artist was awarded a solo exhibition at the Seattle Art Museum, reflects the influence of modern art and her study in Paris with André Lhote (1885–1962) in 1932. Representing the artist's integration of expressionism and cubism, the painting dramatically unfolds above a horizon defined by the majesty of sawtooth mountains and strong contrasts of light and shadow. In their striking interpretations of the latest art movements from Europe, Camfferman and her husband, the artist Peter Camfferman (1890–1957), are considered among the earliest modernist artists working in the Northwest.

Zama Vanessa Helder (1904–1968) is widely known today for her precisionist watercolors commissioned in 1939 by the United States Bureau of Reclamation to document the construction of the Grand Coulee Dam. During this time she was hired by the Work Projects Administration (WPA) to teach at the Spokane Art Center. *Water Tower*, dating from this period, reflects the same mastery of light, sharp focus, and eye for unusual composition that distinguishes her style (fig. 25). Helder's paintings were included in the seminal art exhibition *Realists and Magic Realists*, where her work was exhibited alongside that of Ivan Albright, Edward Hopper, and Andrew Wyeth at the Museum of Modern Art in 1943.

A sharp-edged precisionist style was also adopted by Blanche Morgan Losey (1912–1981), who transposed it to surrealist ends. The artist, who created dramatic stage sets for theatrical productions in Seattle while working for the WPA, turned her attention to dreamlike landscapes such as *Sands of Time* (c. 1945, fig. 26). This painting can also be viewed within the context of the ecological disaster of the Dust Bowl years.

A similar sense of dislocation and timelessness appears in Karin Helmich's painting *White Light* (1971). As a realist painter, Helmich (b. 1943) excels in portraits and landscapes. In this unusual, more abstract work she perhaps interprets

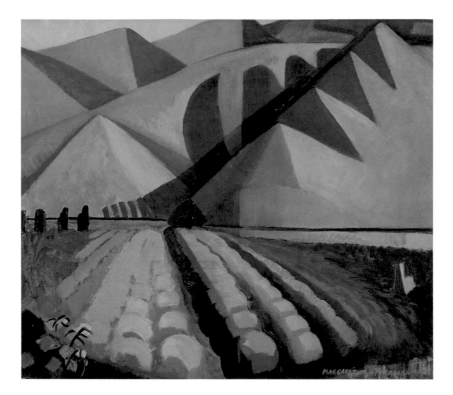

24.
Margaret Camfferman
Untitled (Landscape), 1935
Oil on artist's board
25⅞ × 30 inches

25.
Zama Vanessa Helder
Water Tower, 1930s
Watercolor on paper
17½ × 21¾ inches

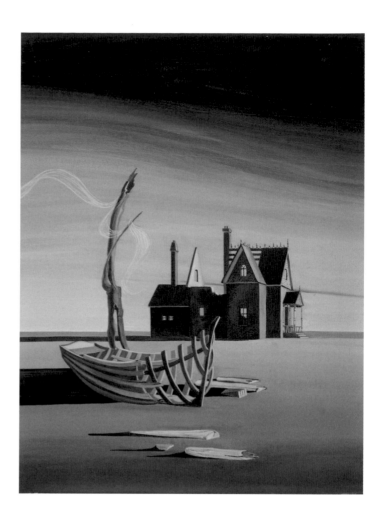

26.
Blanche Morgan Losey
Sands of Time, c. 1945
Tempera on illustration board
20 × 16 inches

the foggy conditions of the Pacific Northwest. However, two white, paperlike forms that cast strong shadows, along with a barely visible lightning-streaked line, remain a mystery.

Yvonne Twining Humber (1907–2004), in her painting *Ruin* (c. 1949, fig. 27), shares the same magic-realist spirit as the New York artist Peter Blume (1906–1992). Humber depicts a brick arcade constructed from the bedrock of red clay cliffs. The remnants of a lost civilization consumed by nature's cycle of reclamation is a theme extending back to Thomas Cole's *The Course of Empire: Desolation* (1836). Humber provides the viewer with an intimate look at the futility of human pursuits, a weighty subject that contrasts with her well-known genre paintings. The artist also created a series of visionary landscapes made from collaged paper that reference abstract underwater, mountain, and cosmic motifs. Another of her legacies is the Twining Humber Award for Lifetime

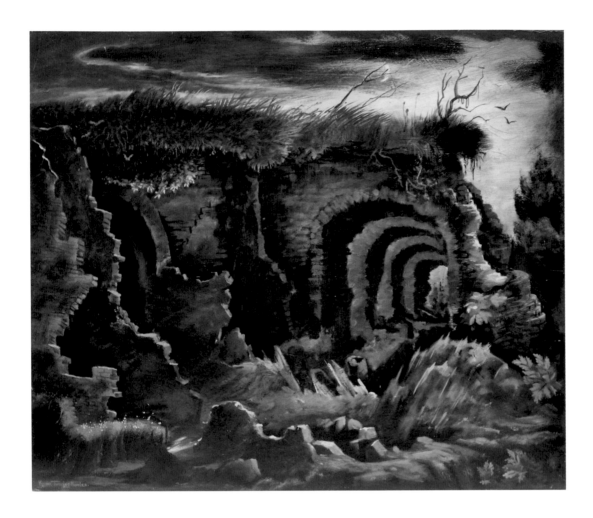

27.
Yvonne Twining Humber
Ruin, c. 1949
Oil on Masonite
24 × 28 inches

Artistic Achievement, given to women artists over sixty years of age, which she endowed before her death in 2004.

The lofty trees of the forest, their fantastic shapes buffeted by the winds along the coast and down the mountain slopes, have long inspired Northwest artists such as Emily Carr, Elizabeth Colborne, Helen Loggie, and Mary Randlett. More recently, deforestation and global warming have motivated contemporary artists Ross Palmer Beecher, Alison Keogh, and Susan Robb to interpret the fate of the forests through unusual iconography and media.

Emily Carr (1871–1945), recognized for her paintings that interpret the art of First Nations in British Columbia, also devoted much of her career to imbuing trees with a spiritual presence. Her studies in London and Paris during the first decade of the twentieth century introduced her to modern art. The color and brushwork of postimpressionist artists inspired her paintings, which are

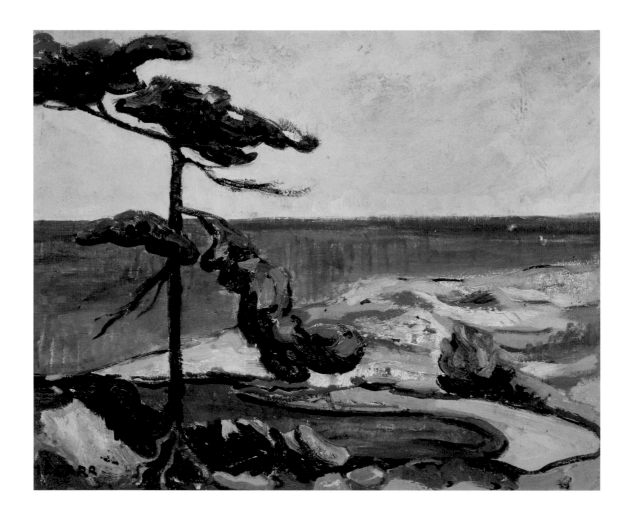

28.
Emily M. Carr
Untitled, c. 1920
Oil on composition board
12¹⁵⁄₁₆ × 16 inches (board)

considered to be among Canada's first modern artworks. Carr's expressionis-
tically painted untitled canvas (c. 1920, fig. 28) contains a life force that corre-
sponds to her artistic approach, as described by the artist: "A main movement
must run through the picture. . . . The movement shall be so great that [the]
picture will rock and sway together, carrying the artist and after him the looker
with it."[20]

A more naturalistic energy runs through the work of Elizabeth Colborne
(1887–1948), who studied in New York at the Pratt Institute and the Art Stu-
dents League. She also spent time on Monhegan Island, Maine, with Rockwell
Kent (1882–1971), who may have inspired the artist's linear style. Colborne
became nationally recognized for her wood-block prints of the mountains
and forests of Whatcom County, which she studied while living in Bellingham.
Many of her graphite drawings of trees, exquisitely detailed and photographic

in clarity, depict individual specimens close-up and from unusual angles. Her tempera painting *The Sisters Peaks of the Cascade Range* (undated) is realistic in its fidelity to color and atmospheric conditions and abstract in its compositional structure (fig. 29).

Helen Loggie (1895–1976) also lived in Bellingham, where she was one of Elizabeth Colborne's art students. She too sought out unusual specimens, such as *The King Goblin* (1939), to personify nature's tenacity and processes of growth. Even after becoming recognized nationally as a printmaker, Loggie made her etchings affordable to the public. Like Colborne, she studied in New York, with Robert Henri, but it was John Taylor Arms (1887–1953), author of the *Handbook of Printmaking and Printmakers* (1934), who exerted the greatest influence on her career. Loggie was celebrated during her lifetime, receiving the Washington State Arts Commission Governor's Award for lifetime achievement in art, and exhibited her work at the Metropolitan Museum of Art and the Whitney Museum of American Art, among a host of other institutions.

Mary Randlett (b. 1924) began her career photographing artists, architects, and writers of the Pacific Northwest, and she later focused her camera on the region's sublime landscapes and atmosphere. From precipitous cliffs down to roiling ocean waves and across mountains whited out with snow, the artist achieves extraordinary effects in black-and-white prints that eschew burning and dodging darkroom techniques. The effects are sometimes reminiscent of the romantic drawings of Victor Hugo (1802–1885), as in *May* (1970), a view of trees clinging to a steep hill shrouded in fog. Her prints have been published in over a hundred books and are in the permanent collections of museums across the country.

In *Haystacks in Balkan Landscape* (1987), Susan Bennerstrom (b. 1949) portrays trees in the more pastoral setting of the European countryside. Her eye for drama and the effects of light and shadow cast the trees as silhouettes in a fleeting atmospheric moment. According to the artist, "This transformative power of light is what my work is about. . . . What we normally perceive as ordinary and familiar can be brooding and unnerving, or else transcendentally sublime."[21]

The fate of the trees in the Pacific Northwest is the subject of an untitled drawing from 1989 by Ross Palmer Beecher (b. 1957). In a style reminiscent of folk art and inspired by the patterning of nineteenth-century samplers, the artist portrays a historical period when the lumber industry dominated the landscape. In this witty drawing, stumps along the riverbank, huge logs carried off by oxen, the steamer delivering more pioneers, and the railroad track that appears to be

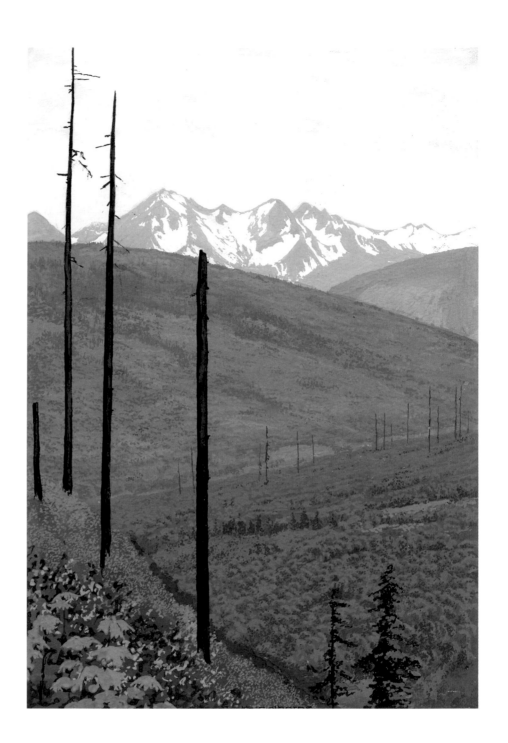

29.
Elizabeth Colborne
The Sisters Peaks of the Cascade Range, undated
Gouache
14 × 11 inches

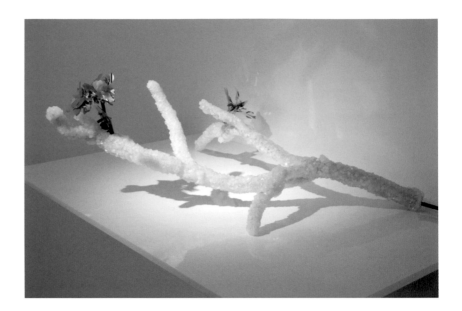

30.
Susan Robb
Gentlest Gesture, 2008
Crystal, muscle wire, circuit board,
Mylar, powder-coated steel shelf
8 × 24 × 17 inches

pulled by an orange-colored horse are framed by towering firs doomed to meet a similar fate. When this drawing was created, the controversy between environmentalists and loggers over listing the northern spotted owl as an endangered species had reached its climax. Palmer, who also creates relief sculptures from found objects that often comment on social issues, has stated that "I question authority with stuff I find in the dumpster."[22]

A more subtle interpretation of the forest's fate can be found in *Newsprint series #4* (2007) by Alison Keogh (b. 1958), in which the artist recycles the financial pages of the *Wall Street Journal* to create rippling landscapes that also correspond to the artist's breath during the work's creation. The felled trees used to produce the newspaper are intuited by the viewer from this unique interpretation. As the artist says: "This series concerns the discovery of nature within the newspaper. It transcends the ordinary daily purpose as a conveyer of 'news' ... and now expresses itself through an altered state of being."[23]

Susan Robb, recognized for her artworks that critique environmental issues, also comments on the relationship between human beings and nature. In the *Gentlest Gesture* (2008, fig. 30), the artist grows Sakura tree branches from crystals and creates a mechanical "life support system" for them, complete with an electronic current that opens and closes purple Mylar "flowers." Of this manipulation and simulation of nature, Robb writes:

> Overall the sense of this work is one of optimism, transformation, and
> mystery. This work was influenced by Neruda's book of poems *Stones*

of the Sky. My work address[es] issues around the American landscape. I was trying to find a way to imagine climate change and its effect on the landscape as a somehow positive thing. When Neruda was dying of cancer he wrote of his body transforming from flesh into crystals into jewels. Its a geologic look at what happens after death (dinosaurs are turned into oil).[24]

~ ~ ~

Show of Hands brings together more than 130 years of work by women artists to offer another perspective on the art of the Northwest. It presents only a partial glimpse of the many talented artists who have contributed to the heritage of the region. For every artist represented, there are many more who have not been included. The exhibition reconfirms the strength of art in this region and the contribution of women to its legacy. The creativity of this gathering of women will, I hope, stimulate insights and observations that will inform future studies on the subject.

1. Video documentary. *Doris Chase, Artist in Motion* (Seattle: University of Washington Press, 1992).

2. *Margaret Tomkins* (Pullman: Washington State University Museum of Art, 1977).

3. Artist statement, http://woodsidebrasethgallery.com/descrip_adkison.html.

4. Regina Hackett and Sean Elwood. *I Surprise Myself: The Art of Elizabeth Sandvig* (Seattle: Francine Seders Gallery, 2007).

5. Mary Ann Peters, *Holding the Moment* (Seattle: James Harris Gallery, 2009).

6. Artist statement, http://www.sedersgallery.com.

7. Artist statement sent to the author.

8. Virna Haffer, *Making Photograms: The Creative Process of Painting with Light* (New York: Hastings House, 1969).

9. Artist statement sent to the author.

10. Laura Cassidy, "Lightness and Being: A Painter Finds Solace in Memory and Seattle's Oceanic Gray," *Seattle Weekly,* June 12, 2002.

11. Artist statement, http://www.sedersgallery.com.

12. Artist statement, http://www.ejameson.com/statement.

13. Artist statement sent to the author.

14. Anita Ventura Mozley, "Imogen Cunningham: Beginnings" in *Discovery and Recognition* (The Friends of Photography, 1981). Available on the Imogen Cunningham Trust website, http://www.imogencunningham.com/BIO/frameset_bio.html.

15. Artist statement sent to the author.

16. Artist statement sent to the author.

17. J. J. Creighton, "Painting for Time," *Columbia Magazine* 17, no. 3 (Fall 2003): 20–23.

18. Artist statement, www.susanpoint.com.

19. "Sketches Coloring of Grand Coulee," *Spokane Spokesman-Review,* July 16, 1934, http://content.wsulibs.wsu.edu/cdm4/item_viewer.php?CISOROOT=/clipping&CISOPTR=8487&CISOBOX=1&REC=1.

20. Anne Newlands, *Emily Carr: An Introduction to Her Life and Art* (Richmond Hill, Ontario: Firefly Books, 1996).

21. www.trogart.com/bennerstrom/bennerstrom-bio.html

22. Artist statement, http://www.arts.wa.gov/projects/masterworks/ross-palmer-beecher.shtml.

23. Regina Hackett, "Alison Keogh, The Art in the Newspaper," December 30, 2008, http://blog.seattlepi.com/art/archives/158225.asp.

24. Artist statement sent to the author.

Checklist of the Exhibition

Maria Frank Abrams
Born 1924
City Structures,1959
Tempera and ink on
paper
21 × 24 in. (unframed)
Whatcom Museum, gift
of the artist (2008.78.2)

Maria Frank Abrams
Untitled, 1977
Graphite on paper
13¼ × 21¼ in.
Whatcom Museum, gift
of the artist (2008.78.3)

Kathleen Gemberling
Adkison
Born 1920
Fire Rock, 1981
Oil on canvas
48 × 70 in.
Whatcom Museum, gift
of Safeco Corporation
(1996.72.1)

Eliza Barchus
1857–1959
Untitled, c. 1890
60½ × 80½ in.
Whatcom Museum,
anonymous gift (X.1213.1)

Harriet Foster Beecher
1854–1915
*Alameda, October 19,
1880*
Oil on paper
20 × 26 in. (framed)
Courtesy of the Museum
of History and Industry,
Seattle

Harriet Foster Beecher
A Camp on the Tide Flats,
1897
Watercolor on paper
13½ × 27 in.
Courtesy of the Museum
of History and Industry,
Seattle

Ross Palmer Beecher
Born 1957
Untitled, 1989
Crayon on paper
23 × 29 in.
Whatcom Museum,
anonymous gift
(X.3761.1)

Susan Bennerstrom
Born 1949
*Haystacks in Balkan
Landscape*, 1987
Pastel
33¾ × 43¾ in.
Whatcom Museum, gift
of Richard Hammond
(1997.61.1)

Marsha Burns
Born 1945
Untitled, 1978
Gelatin silver print
11 × 14 in.
Collection of Nicolette
Bromberg

Margaret Camfferman
1881–1964
Untitled (Landscape),
1935
Oil on artist's board
25⅞ × 30 in.
Tacoma Art Museum,
gift of Maureen Duryee

Emily M. Carr
1871–1945
Untitled, c. 1920
Oil on composition
board
12¹⁵⁄₁₆ × 16 in. (board)
Henry Art Gallery,
University of Washing-
ton, Seattle, gift of
Mrs. Viola Patterson
(FA 68.34)

Lauri Chambers
Born 1951
Untitled #4, 1992
Oil and graphite on
Masonite
48 × 48 in.
Collection of Pat Scott

Doris Chase
1923–2008
Encircled, 1968
Laminated fir
H: 10 ft.
Courtesy of the Wash-
ington State Convention
Center

Doris Chase
Video transfers to DVD:
Intro to Sculpture series
1974–84, 7 min.
Moon Redefined, 1979,
5 min. 30 sec.
Jazz Dance, 1979, 4 min.
Plexi Gate, 1980, 7 min.
Courtesy of Randall
Chase

Diem Chau
Born 1979
Empty Hand, 2009
Silk organza, thread, and
porcelain plate
5¾ × 4¼ × ¾ in.
Courtesy of the artist
and G. Gibson Gallery,
Seattle

Diem Chau
Girl, 2009
Silk organza, thread, and
porcelain dish
5¾ × 5¾ × 1 in.
Courtesy of the artist
and G. Gibson Gallery,
Seattle

Diem Chau
Given, 2009
Silk organza, thread, and
porcelain plate
6 × 6 × ¾ in.
Courtesy of the artist
and G. Gibson Gallery

Elizabeth Colborne
1887–1948
*The Sisters Peaks of the
Cascade Range*, undated
Gouache
14 × 11 in.
Whatcom Museum, gift
of the Bellingham Public
Library (1976.62.11)

Elizabeth Colborne
Untitled (Pine), undated
Pencil
12½ × 9½ in.
Whatcom Museum, gift
of the Bellingham Public
Library (1976.62.27)

Claire Cowie
Born 1975
Rhinoscape, 2006
Foam, acrylic medium,
gesso, and watercolor
39 × 26 × 72 in.
Collection of Carol I.
Bennett

Claire Cowie
The Rainbow, 2008
Watercolor, sumi ink,
and pencil on paper
47 × 40 in.
Courtesy of James Harris
Gallery

Louise Crow
1891–1968
*Eagle Dance at San
Ildefonso*, 1919
Oil on canvas
71½ × 95½ in.
Collection of David F.
Martin and Dominic
Zambito

Imogen Cunningham
1883–1976
Flax, c. 1920
Gelatin silver print
6½ × 4½ in.
Courtesy of the Imogen
Cunningham Trust and
G. Gibson Gallery

Imogen Cunningham
*Three Dancers, Mills
College*, 1929
Gelatin silver print
7 × 8½ in.
Courtesy of the Imogen
Cunningham Trust and
G. Gibson Gallery

Imogen Cunningham
Fageol Ventilators, 1934
Gelatin silver print
7½ × 9½ in.
Courtesy of the Imogen
Cunningham Trust and
G. Gibson Gallery

Imogen Cunningham
*Nuns at Alexander Calder
Show*, 1953
Gelatin silver print
7½ × 7¼ in.
Courtesy of the Imogen
Cunningham Trust and
G. Gibson Gallery

Imogen Cunningham
Civil Rights March, 1963
9½ × 7¼ in.
Gelatin silver print
Courtesy of the Imogen
Cunningham Trust and
G. Gibson Gallery

Imogen Cunningham
Dream Walking, 1968
Gelatin silver print
9½ × 10¾ in.
Courtesy of Joshua
Partridge and G. Gibson
Gallery, Seattle

Marita Dingus
Born 1956
*200 Women of African
Descent*, 1994
Mixed media
Each: 10 × 3 × 1½ in.
Seattle Art Museum, gift
of the artist and Francine
Seders Gallery

Caryn Friedlander
Born 1955
North Shore, 2007
Pastel on paper
12¾ × 13½ in. (framed)
Courtesy of the artist
and Francine Seders
Gallery

Anna Gellenbeck
1883–1948
*Richardson Highway,
Alaska*, 1944
Oil on canvas
37⅝ × 35¹¹⁄₁₆ in.
Washington State
Historical Society

Virna Haffer
1899–1974
Abstract #15, c. 1960
Photogram
20 × 16 in.
Washington State
Historical Society

Sally Haley
1908–2007
Untitled (abstract
window), 1960
Oil on canvas
32 × 26 in.
Courtesy of Laura Russo
Gallery

Victoria Haven
Born 1964
Site-specific wall
painting for the What-
com Museum, 2010
Ink, tape, and paint on
wall
70 × 64 in.
Courtesy of the artist
and Greg Kucera Gallery

Zama Vanessa Helder
1904–1968
Water Tower, 1930s
Watercolor on paper
17½ × 21¾ in.
Private collection,
courtesy of Martin-
Zambito Fine Art

Karin Helmich
Born 1943
White Light, 1971
Oil on canvas
26¼ × 42½ in.
Collection of the
Whatcom Museum
(1979.18.1)

Mary Henry
1913–2009
Linear Series #5, 1966
Acrylic on canvas
50 × 72 in.
Howard House Contem-
porary Art

Mary Henry
On/Off 8A On/Off 8B,
1967
Acrylic on canvas
Each: 60 × 60 in.
PDX Contemporary Art

Mary Henry
Ilya On My Mind, 1990
Acrylic on canvas
72 × 96 in.
Howard House Contem-
porary Art

Abby Williams Hill
1861–1943
Horseshoe Basin, 1903
Oil on canvas
41⅛ × 28³⁄₁₆ in.
University of Puget
Sound, Tacoma

Abby Williams Hill
Lake Louise, 1926
Oil on canvas
18 × 26 in.
University of Puget
Sound, Tacoma

Anne Hirondelle
Born 1944
Dance Diptych, 1991
Glazed stoneware
18½ × 26 × 9 in.
Collection of Gale and
Susann Schwiesow

Anne Hirondelle
Tumble #10, 2009
Unglazed stoneware and
paint
10 × 9½ × 7 in.
Courtesy of the artist
and Francine Seders
Gallery

Yvonne Twining Humber
1907–2004
Ruin, c. 1949
Oil on Masonite
24 × 28 in.
Whatcom Museum, gift
of David F. Martin and
Dominic A. Zambito in
memory of the artist

Elizabeth Jameson
Born 1962
Forecasting Queen, 2009
Charcoal and pastel on
paper
100 × 84 in.
Courtesy of Fetherston
Gallery

Fay Jones
Born 1936
Crows, Scarecrows, 1974
Acrylic and graphite on
paper
10 × 9⅛ in.
Collection of Francine
Seders

Fay Jones
Loss, 1991
Acrylic, sumi, and collage
on perforated paper
55 × 78 in. (framed)
Collection of Susan
Grover

Helmi Dagmar Juvonen
1903–1985
Northwest Coast Mask,
c. 1947
Mixed media
21½ × 22⅞ in. (framed)
Washington State
Historical Society

Helmi Dagmar Juvonen
Petroglyph, 1967–68
Watercolor on paper
22 × 15 in.
Whatcom Museum,
gift of Ulrich and Stella
Fritzsche (2009.91.1)

Ruth Kelsey
1905–2000
Chief Red Star, 1941
Oil on canvas
34⅞ × 28¾ in. (framed)
Washington State
Historical Society

Alison Keogh
Born 1958
Newsprint series #4, 2007
Newsprint and ink on
board
30 × 30 × 2 in.
Courtesy of the artist

Maude Kerns
1876–1965
Composition #31, 1944
Oil on canvas
24 × 18 in.
Gift of Pauline and
Robert Forsyth, collec-
tion of Jordan Schnitzer
Museum of Art, Univer-
sity of Oregon, Eugene
(1993:1.13)

Maude Kerns
*Composition #85 (In
and Out of Space)*, 1951
Oil on canvas
28 × 22 in.
Gift of the Estate of
Maude I. Kerns, collec-
tion of Jordan Schnitzer
Museum of Art, Univer-
sity of Oregon, Eugene
(1969:8.7)

Sheila Klein
Born 1952
Stand, 2000
Nylon, Lycra, spandex,
and steel
13 × 13 × 9 ft.
Courtesy of the artist

Sheila Klein
Textile Wallah, 2009
Tea-dyed cotton twine
88 in. × 12 ft. 9 in. × ¼ in.
Courtesy of the artist

Gwendolyn Knight
1913–2005
Mask IV, 1988
Oil on canvas
19 × 17¼ in. (framed)
Microsoft Art Collection

Margot Quan Knight
Born 1977
Sur face (bubbles), 2009,
1 min., 20 sec.
Sur face (paper), 2009,
53 sec.
Color videos
Courtesy of James Harris
Gallery

Margie Livingston
Born 1953
Four *Angle, Drizzle, and
Dot* paintings, 2010
Each: 25 × 30 in.
(approx.)
Acrylic and adhesive
Courtesy of the artist
and Greg Kucera Gallery

Helen Loggie
1895–1976
The King Goblin, 1939
Etching
9¹⁄₁₆ × 12⅜ in.
Gift of Robert D. Frazier,
1991, collection of
Western Gallery, West-
ern Washington
University

Helen Loggie
Hosanna, 1960
Etching
12½ × 9¼ in.
Whatcom Museum
(2003.98.2)

Helen Loggie
Hosanna, 1960
Etching plate
8¾ × 12 in.
Whatcom Museum,
gift of Barbara Robbins
(1996.89.31)

Blanche Morgan Losey
1912–1981
Sands of Time, c. 1945
Tempera on illustration
board
20 × 16 in.
Private collection

Sherry Markovitz
Born 1947
Porcelain Lamb, 1979
Gouache on layered rice
paper
43 × 44 in. (framed)
Collection of the artist

Sherry Markovitz
Mourning You/Morning Ewe, 2007
Mixed media
19 × 15 × 17 in.
Private collection

Agnes Martin
1912–2004
Untitled, 1965
Pencil on paper
9 × 8⅝ in.
Washington Art Consortium: Henry Art Gallery, University of Washington, Seattle; Museum of Art, Washington State University, Pullman; Northwest Museum of Arts and Culture, Spokane; Seattle Art Museum; Tacoma Art Museum; Western Gallery, Western Washington University, Bellingham; Whatcom Museum, Bellingham

Ella McBride
1862–1965
Nasturtium, 1920s
Chloride print
7⅝ × 9½ in.
Private collection

Lucinda Parker
Born 1942
Snags, 2006
Acrylic on canvas
85 × 42 in.
Courtesy of Linda Hodges Gallery

Viola Patterson
1898–1984
Untitled, 1954
Oil on canvas board
18½ × 29½ in.
Whatcom Museum, gift of Joan Wahlman (2007.115.9)

Mary Ann Peters
Born 1949
In an instant. . . a delicate balance, 2006
Gouache, watercolor, and pencil on polypropylene paper
75 × 54 in.
Collection of Judy Tobin and Michael Baker

Susan Point
Born 1952
River Worn by Time, 2002
Serigraph
28 × 7 in.
Gift of W. A. Douglas Jackson, 2006, collection of Western Gallery, Western Washington University

Mary Randlett
Born 1924
May, 1970
Silver gelatin print
8½ × 13¼ in.
Whatcom Museum, gift of the artist (1970.135.1)

Ebba Rapp
1909–1985
Totem of Rumor, c. 1950
Oil on canvas
51¾ × 31 in.
Washington State Historical Society

Susan Robb
Gentlest Gesture, 2008
Crystal, muscle wire, circuit board, Mylar, powder-coated steel shelf
8 × 24 × 17 in.
Collection of Yoshimi Ott

Elizabeth Sandvig
Born 1937
Broken Columns, early 1970s
Screen mesh
32 × 15 × 7 in.
Collection of the Museum of Northwest Art, gift from the Blair and Lucille Kirk Collection

Elizabeth Sandvig
Born 1949
Peaceable Kingdom I, 2003
Oil on canvas
38 × 45 in.
Courtesy of the artist and Francine Seders Gallery

Norie Sato
Born 1949
Paused Field, 1979
Mixed media on paper
25½ × 31½ in.
Collection of the Whatcom Museum, purchase was jointly supported with funds provided by the National Endowment for the Arts and the Whatcom Museum Society (1979.48.1)

Barbara Sternberger
Born 1957
Immediate, 2008
Oil on panel
12 × 12 in.
Courtesy of the artist and Elizabeth Leach Gallery

Maki Tamura
Born 1973
Moonlight Spell, 2008
Watercolor on paper
29½ × 38 in.
Courtesy of James Harris Gallery

Barbara Earl Thomas
Born 1948
A Man Cleaning His Fish, 1987
Egg tempera on paper
23¾ × 36½ in. (framed)
Collection of Jane Ellis and Jack Litewka

Barbara Earl Thomas
A Fire in the Landscape, 2002
Tempera on paper
21½ × 48¼ in. (framed)
Private collection and Francine Seders Gallery

Margaret Tomkins
1916–2002
Untitled, 1949
Oil on canvas
14 × 26 in.
Phil and Mary Serka Collection

Margaret Tomkins
Twice Sun White, 1963
Oil on canvas
45 × 60½ in.
Whatcom Museum, gift of the Virginia Wright Fund (1976.48.27)

Margaret Tomkins
Quantum, 1979
Acrylic on canvas
79¼ × 79¼ in.
Courtesy Gordon Woodside/John Braseth Gallery

Gail Tremblay
Born 1945
An Iroquois Dreams That the Tribes of the Middle East Will Take the Message of Deganawida to Heart and Make Peace, 2009
16mm film, leader, rayon cord, and thread
24 × 14 × 14 in.
Courtesy of the artist and Froelick Gallery

Patti Warashina
Born 1940
Diamond in the Rough, 1988
Fired ceramic white ware with under glazes
10½ × 18¾ × 14⅞ in. (22 × 19⅛ × 15½ in. with Plexi box)
Collection of Robert and Shaké Sarkis

Patti Warashina
Bonded Flight, 2006
Bronze
30 × 25 × 18 in.
Howard House Contemporary Art

Marie Watt
Born 1967
Blanket Stories: Ladder, Great Registry, Oregon Trail, Long Haul and All My Relations, 2008
Reclaimed cedar and wool blankets
Dimensions variable
Courtesy of Greg Kucera Gallery and PDX Contemporary Art

Myra Albert Wiggins
1869–1956
Alaska, c. 1899
Platinum print
4 × 5 in.
Private collection

Ellen Ziegler
Born 1949
Hypnagogue 3, 2009
Mirrored glass, light, and shadow
24 × 3 in. and 8 × 13 in.
Courtesy of the artist

Bibliography

Adkins, Gretchen. "The Aquaria of Anne Hirondelle." *Ceramics Art and Perception* 31: 44–46.

Alison Keogh: Breathing Rhythm, 2009.

Ament, Deloris Tarzan. *Susan Bennerstrom: Existing Light*. Bellingham, WA: Whatcom Museum of History and Art, 2002.

——. *Iridescent Light: The Emergence of Northwest Art*. Seattle: University of Washington Press, 2002.

Brunsman, Laura, and Ruth Askey, eds. *Modernism and Beyond: Women Artists of the Pacific Northwest*. New York: Midmarch Arts Press, 1993.

Cassidy, Laura. "Lightness and Being: A Painter Finds Solace in Memory and Seattle's Oceanic Gray." *Seattle Weekly*, June 12, 2002.

Conkelton, Sheryl, and Barbara Earl Thomas. *Never Late for Heaven: The Art of Gwen Knight*. Seattle: University of Washington Press, 2003.

Cowles, Charles, Martha Kingsbury, and Sarah Clark. *Northwest Traditions*. Seattle: Seattle Art Museum, 1978.

Creighton, J. J. "Painting for Time." *Columbia Magazine* 17, no. 3 (2003): 23–26.

——. *Indian Summers: Washington State College and the Nespelem Art Colony 1937–41*. Pullman: Washington State University Press, 2000.

Failing, Patricia. *Doris Chase, Artist in Motion: From Painting and Sculpture to Video Art*. Seattle: University of Washington Press, 1991.

Farr, Shelia. *Fay Jones*. Seattle: Grover/Thurston Gallery and Laura Russo Gallery in association with University of Washington Press, 2000.

Fassi, Luigi. *Margot Quan Knight*. Verona: Galleria d'arte Moderna Palazzo Forti, 2007.

Ferrell, Heather. *Lucinda Parker: New Paintings*. Boise: Boise Art Museum, 2002.

Fields, Ronald. *Abby Williams Hill and the Lure of the West*. Tacoma: Washington State Historical Society, 1989.

Fritzsche, Ulrich. *Helmi Dagmar Juvonen, Her Life and Work: A Chronicle*. Seattle, 2001.

Gilbert, Courtney. *Modern Parallels: The Paintings of Mary Henry and Helen Lundeberg*. Hailey, ID: Sun Valley Center for the Arts, 2009.

Guenther, Bruce. *50 Northwest Artists*. San Francisco: Chronicle Books, 1983.

Hackett, Regina, and Sean Elwood. *I Surprise Myself: The Art of Elizabeth Sandvig*. Seattle: Francine Seders Gallery in association with University of Washington Press, 2007.

Hackett, Regina, and Sondra Shulman. *Fay Jones: A 20 Year Retrospective*. Boise: Boise Art Museum, 1996.

Halper, Vicki. *Warashina*. Bellevue, WA: Bellevue Art Museum, 1991.

Hopkins, Terri. *Sally Haley: A Lifetime of Painting*. Marylhurst, OR: The Art Gym, Marylhurst University, 1993.

Hopkins, Terri M., Lois Allen, and Matthew Kangas. *Northwest Matriarchs of Modernism: 12 Proto-Feminists from Oregon and Washington*. Marylhurst, OR: The Art Gym, Marylhurst University, 2004.

Johns, Barbara, ed. *Jet Dreams: Art of the Fifties in the Northwest*. Tacoma: Tacoma Art Museum; Seattle: distr. University of Washington Press, 1995.

Johnston, Thomas Alix, and Dorothy Kobert. *Beyond the Veil: The Etchings of Helen Loggie*. Bellingham, WA: Whatcom Museum of History and Art, 1979.

Kangas, Matthew. *Kathleen Gemberling Adkison*. Bellingham, WA: Whatcom Museum of History and Art, 1996.

——. *Patti Warashina: Recent Work*. Tucson: Tucson Museum of Art; Seattle: Forward Press, 1982.

Kew, Michael, Peter MacNair, Vesta Giles, and Bill McLennan, eds. *Susan Point, Coast Salish Artist*. Vancouver/Toronto: Douglas & McIntyre; Seattle: University of Washington Press, 2000.

Kingsbury, Martha. *Art of the Thirties: The Pacific Northwest*. Seattle: University of Washington Press and Henry Art Gallery, 1972.

Kingsbury, Martha, and Centennial Year Exhibition Guide. *Celebrating Washington's Art*. Olympia: Washington Centennial Commission, 1989.

Kovinick, Phil, and Marian Yoshiki-Kovinick. *An Encyclopedia of Women Artists of the American West*. Austin: University of Texas Press, 1998.

Lorenz, Richard. *Imogen Cunningham: The Modernist Years*. Tokyo: Treville Company, 1993.

Markovitz, Sherry. *Shimmer*. Pullman: Museum of Art, Washington State University, 2008.

Martin, David F. *Pioneer Women Photographers*. Seattle: Frye Art Museum, 2002.

Martin, David F. "Yvonne Twining Humber: A Washington Painter of Renown and Obscurity." *Columbia Magazine* 23, no. 4 (2009–10): 19–25.

——. "Helder, Z. Vanessa (1904–1968)." HistoryLink. org: The Free Online Encyclopedia of Washington State History. http://www.historylink.org/index .cfm?DisplayPage=output.cfm&file_id=8633 (accessed February 1, 2010).

Martin, David F., and Whatcom Museum of History and Art. *An Enduring Legacy: Women Painters of Washington, 1930–2005*. Seattle: University of Washington Press, 2005.

Mary Randlett: Landscapes. Seattle: University of Washington Press in association with the Tacoma Art Museum, 2007.

McCaffrey, Frank. *Some Work of the Group of Twelve*. Seattle: Dogwood Press, 1937.

Mozley, Anita Ventura. "Imogen Cunningham: Beginnings" in *Discovery and Recognition*. The Friends of Photography, 1981.

Newlands, Anne. *Emily Carr: An Introduction to Her Life and Art*. Richmond Hill, Ontario: Firefly Books, 1996.

Peters, Mary Ann. *Holding the Moment*. Seattle: James Harris Gallery, 2009.

Sharylen, Maria. *Artists of the Pacific Northwest: A Biographical Dictionary, 1600s–1970*. Jefferson, NC: McFarland & Company, 1993.

Sheila Klein. Encyclopedia Destructica, 2009.

Storm Watch: The Art of Barbara Earl Thomas. Seattle: University of Washington Press, 1998.

Tesner, Linda Brady. *Objects Between Subjects: Shelia Klein*. Portland: Gallery of Contemporary Art, Lewis and Clark College, 2002.

Trenton, Patricia, ed. *Independent Spirits: Women Painters of the American West, 1890–1945*. Los Angeles: University of California Press, 1995.

Turk, Rudy, and R. Mike Johns. *Patti Warashina: A Survey Exhibition 1962–1993*. Scottsdale, AZ: Bentley/ Tomlinson Gallery, 1993.

Watkinson, Patricia Grieve, and Tom Robbins. *Margaret Tomkins*. Pullman: Museum of Art, Washington State University, 1977.

Wehr, Wesley. "Helmi: Letters from Elma." *Columbia Magazine* 14, no. 2 (2000): 24–31.

Wehr, Wesley, Delbert J. McBride, and Martha Kingsbury. *Helmi Juvonen: Observations and Transformations*. Olympia: Washington State Capitol Historical Association and Evergreen State College, 1984.

West, Harvey, ed. *The Washington Year: A Contemporary View, 1980–1981*. Seattle: Henry Art Gallery, University of Washington, 1982.

Zenter, Barbara Scott, and Mimi Bell, Barbara Johns, Paul Bolin, and Robert J. Forsyth. *Maude Irvine Kerns 1876–1965*. Eugene, OR: Maude Kerns Art Center, 1988.

Photographic Credits

Fig. 1. Courtesy of the Jordan Schnitzer Museum of Art, University of Oregon, Eugene

Fig. 2. Courtesy of PDX Contemporary Art

Fig. 3. Courtesy of Randall Chase

Figs. 4 and 11. © Spike Mafford

Fig. 5. © David Scherrer

Fig. 6. © Jim Lommasson

Fig. 7. Courtesy of the Museum of Northwest Art

Figs. 8, 9, 10, 24, and 28. © Richard Nicol

Fig. 12. © Roger Schreiber

Fig. 13. © Joshua Partridge

Fig. 14. © Sherry Markovitz

Fig. 15. © Robert Reynolds

Fig. 16. © Michael Ryan

Figs. 17, 20, 25, 26, and 27. © David F. Martin

Figs. 18, 19, and 23. Courtesy of the Washington State Historical Society

Fig. 21. Courtesy of the Museum of History and Industry, Seattle

Fig. 22. Courtesy of the University of Puget Sound, Tacoma

Fig. 29. Courtesy of the Whatcom Museum

Fig. 30. Courtesy of Lawrimore Project

Lenders to the Exhibition

Abby Williams Hill Collection, University of Puget Sound

Carol I. Bennett

Nicolette Bromberg

Randall Chase

Elizabeth Leach Gallery

Jane Ellis and Jack Litewka

Fetherston Gallery

Francine Seders Gallery

Caryn Friedlander

Friesen Gallery

Froelick Gallery

G. Gibson Gallery

Gordon Woodside / John Braseth Gallery

Greg Kucera Gallery

Susan Grover

Victoria Haven

Howard House Contemporary Art

Imogen Cunningham Trust and G. Gibson Gallery

James Harris Gallery

Jordan Schnitzer Museum of Art, University of Oregon

Alison Keogh

Sheila Klein

Laura Russo Gallery

Linda Hodges Gallery

Margie Livingston

Sherry Markovitz

David F. Martin and Dominic Zambito

Martin-Zambito Fine Art

Microsoft Art Collection

Museum of History and Industry, Seattle

Museum of Northwest Art

Yoshimi Ott

Joshua Partridge and G. Gibson Gallery

PDX Contemporary Art

Robert and Shaké Sarkis

Gale and Susann Schwiesow

Pat Scott

Seattle Art Museum

Francine Seders

Phil and Mary Serka

Barbara Sternberger

Tacoma Art Museum

Judy Tobin and Michael Baker

Gail Tremblay

Washington Art Consortium: Henry Art Gallery, University of Washington, Seattle; Museum of Art, Washington State University, Pullman; Northwest Museum of Arts and Culture, Spokane; Seattle Art Museum; Tacoma Art Museum; Western Gallery, Western Washington University, Bellingham; Whatcom Museum, Bellingham

Washington State Convention Center

Washington State Historical Society

Western Gallery, Western Washington University

Whatcom Museum

Ellen Ziegler